THE Royal Pavilion at Brighton.

Published by the Command of &
dedicated by Permission to the

KING.

by His Majesty's
dutiful Subject and Servant,

John Nash

JOHN NASH

VIEWS OF THE ROYAL PAVILION

Introduction and Commentary by Gervase Jackson-Stops

Foreword by HRH The Prince of Wales

PAVILION

First published in Great Britain in 1991 by
PAVILION BOOKS LIMITED
196 Shaftesbury Avenue, London WC2H 8JL

Designed by Lawrence Edwards

A CIP catalogue record for this book is available
from the British Library

ISBN 1 85145 583 3
Printed and bound in Germany by Mohndruck

10 9 8 7 6 5 4 3 2 1

Contents

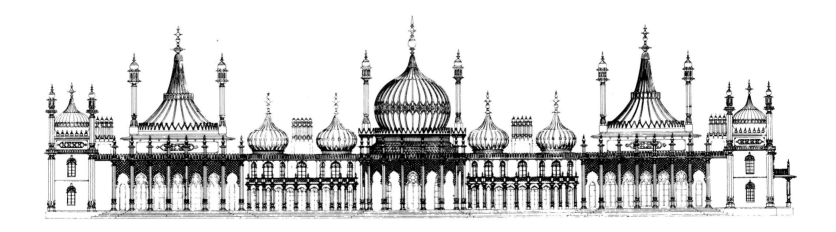

Foreword by HRH The Prince of Wales

AT A TIME *when humour and fantasy are at last beginning to creep back into our architecture, after the boredom and sterility of the Modern Movement office block, we can begin to see the Royal Pavilion at Brighton in a truer perspective: not simply as an extravagant joke, but as a highly original and considered work of art.*

George IV, its creator, is himself due for reassessment. The somewhat ludicrous figure portrayed by Gillray (not the first or last time a Prince of Wales has suffered at the hands of the cartoonist!) is too often accepted at face value. Yet, quite apart from his passion for music and literature, and his friendship with men like Sheridan, Kemble and Charles James Fox, he also remains the greatest builder and collector my family has ever produced, outrivalling even Charles I as a collector.

It is hard to turn a corner at Buckingham Palace or at Windsor Castle without being reminded of his legacy, and I am constantly astonished at the width of his taste. From Italian and Spanish pictures to French furniture, from Flemish bronzes and German ivories to Russian hardstones, he showed the way for some of the great museum directors of the later nineteenth century.

But to understand the Prince Regent fully, and his contribution to the taste we rightly call Regency, you have to go to Brighton. The gradual transformation of Henry Holland's polite 'marine villa' into John Nash's wild oriental fantasy – a riot of verandahs, onion domes and minarets – echoes his own escape from the restricting conventions of his time to an exotic new world of the imagination. Besides his infallible eye for works of art, he could also spot the architects, artists and craftsmen capable of making these dreams a reality.

When the finishing touches were being put to it in 1823, the King confessed that he cried for joy when he contemplated the Pavilion's splendours. Queen Victoria was not so amused, and, after her move to Osborne with the Prince Consort, the building only narrowly escaped demolition, thanks to the Brighton Town Commissioners who purchased it for use as assembly rooms, and

for opening to the public. Weathering a long period of critical (and structural) neglect, the Pavilion only began to come back into its own earlier this century, when Regency taste was once more the vogue.

My great-grandmother, Queen Mary, was a frequent visitor, encouraging moves to restore the interior to its original appearance. I am delighted that many works of art made for particular rooms in the Pavilion have since been returned on loan from the Royal Collection, and that copies have also been made of some of the original chimneypieces taken to Buckingham Palace in the 1840s.

The meticulous work of the restorers in recent years (and especially since the tragic fire, which so nearly destroyed the Music Room in 1975) has been greatly aided by the existence of the hand-coloured aquatints in Nash's Views of the Royal Pavilion. *This magnificent picture-book, commissioned by George IV for presentation to particular friends and guests, shows the rooms in their final state, resplendent with gilded*

ornament, brilliantly coloured textiles and blazing chandeliers. A measure of the pride the King took in his creation, it must be one of the most elaborate publications ever devoted to a single building.

Copies of the Views *are now of course extremely rare – and exceptionally valuable. So I greatly welcome the initiative taken by Pavilion Books in republishing this beautiful and fascinating volume, as a celebration of their tenth birthday. Gervase Jackson-Stops' inimitable room-by-room commentary helps us to understand how the Pavilion was used as well as decorated, and our glimpses of 'Prinny' dining with his friends in the Banqueting Room (with Nash among them), the French chef's sauces gently simmering on the patent 'steam tables' in the Great Kitchen, or fashionable Brighton society parading outside William Porden's 'Indian' stable block, give a picture of Regency life that is hard to equal.*

SECTION THROUGH

THE STATE APARTMENTS

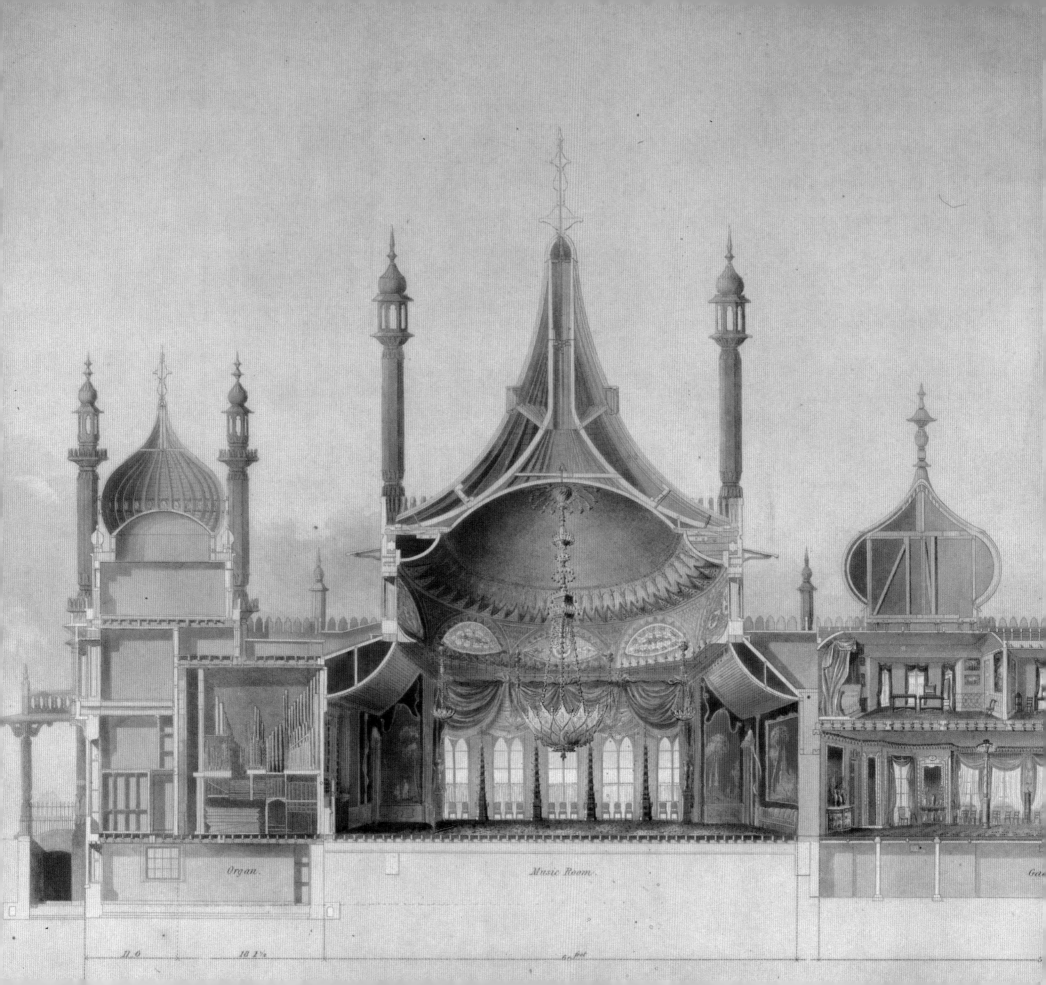

Organ. Music Room.

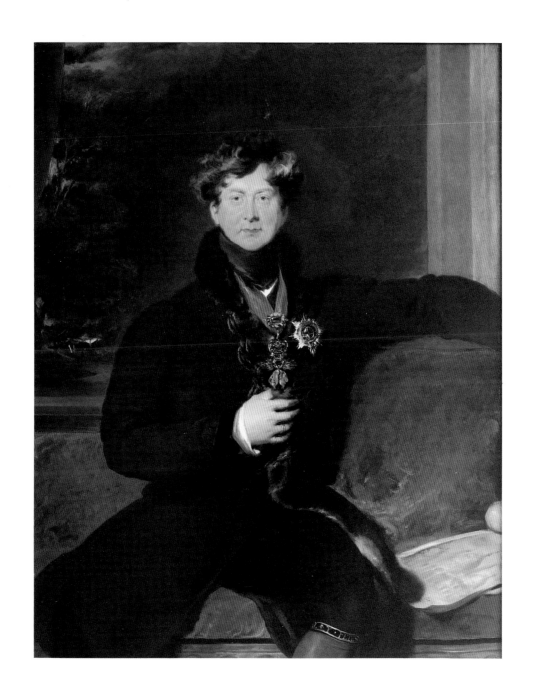

THE PRINCE REGENT,
by Sir Thomas Lawrence

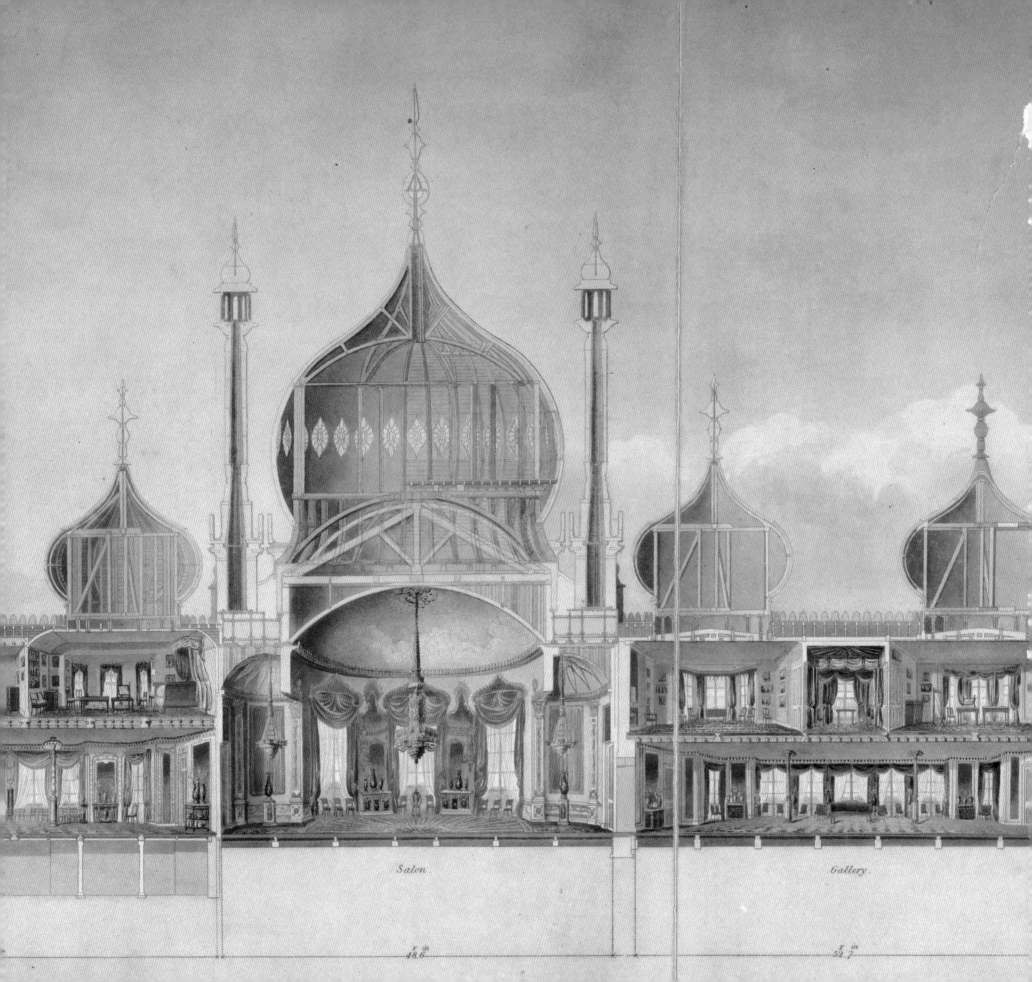

Salon.

Gallery.

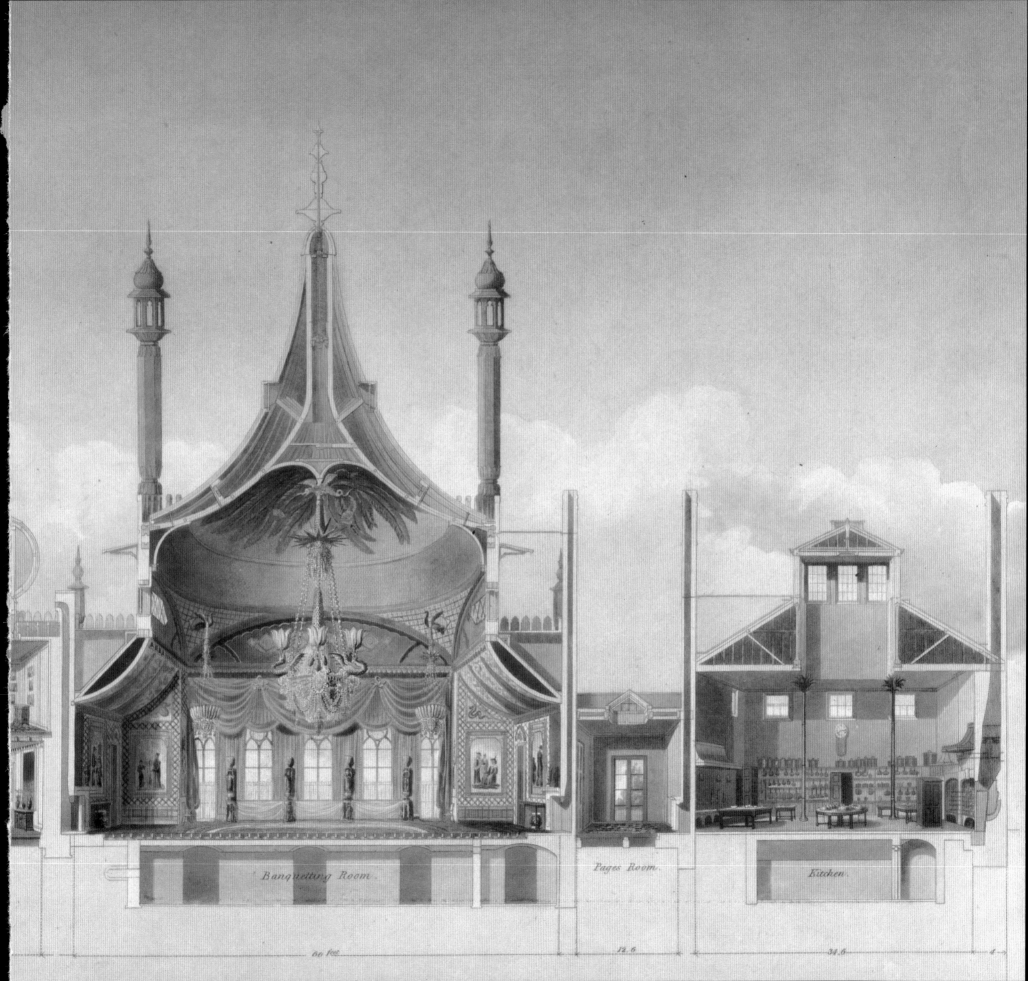

Banquetting Room.

Pages Room.

Kitchen.

60 feet.

12.6

34.6

Introduction by Gervase Jackson-Stops

THERE CAN BE FEW buildings in the world that are more instantly recognizable, or that more vividly recall the character of their creator, than George IV's Royal Pavilion at Brighton. Astonishing and amusing in equal quantities, insubstantial in its fantasy yet monumental in its scale, this greatest of Regency follies seems the embodiment of 'Prinny' himself: occasionally verging on the absurd, but more than redeemed by the charm and humour, the intelligence and style of "the first gentleman of Europe".

The fishing village of Brighthelmstone had first begun to attract the *beau monde* in the 1750s when Dr Richard Russell of Lewes advocated the health-giving properties of its sea-water, both for bathing and drinking. Lacking the stuffiness of spas like Bath and Tunbridge Wells, it soon attracted the attention of George III's dissolute brothers, the Dukes of Gloucester and Cumberland, and it was they who introduced the young Prince of Wales to its pleasures soon after his twenty-first birthday in 1783. His secret marriage to Mrs Fitzherbert is thought to have taken place the following year, and thereafter she and the Prince spent several months at Brighton each summer – though naturally living in separate houses for the sake of appearances.

The Prince's 'Marine Pavilion' – originally a modest farmhouse, enlarged by Henry Holland in 1787 – was never conceived as a formal royal palace, set apart from its neighbours, but as a seaside house intended for uninhibited enjoyment. To begin with, its interiors were in the French neo-classical style of Carlton House, his London residence. But from 1802 the rooms were transformed – first by Frederick Crace and then also by Robert Jones – in an increasingly exotic chinoiserie style: a wilderness of simulated bamboo and imitation lacquer, dragons, mandarins and pagodas, summing up an idealized vision of the Orient.

In 1803, a huge new stable block was built by the architect William Porden in the Indian style, and it was this that dictated the final transformation of the Pavilion by John Nash between 1815 and 1822. Adding huge square Banqueting and Music Rooms at either end of Holland's villa, with their curious 'tented' roofs, he went on to embellish the low existing building with a forest of onion domes and minarets, turrets and pinnacles, loosely based on the Indian buildings seen in Thomas and William Daniell's *Oriental Scenery*. The resulting skyline, audacious and improbable, gave a picturesque unity to the whole building. It was also achieved by pioneering technology, such as the cast-iron frame construction supporting the dome over the central saloon.

In 1820, before the building was entirely finished, the new King's excitement and enthusiasm for the project was at its height, and it seems to have been at this point that a volume commemorating the building was first conceived. Whether the idea was Nash's or George IV's is not entirely clear. When the book finally appeared in 1826, it was entitled *The Royal Pavilion at Brighton, published by the command of and dedicated by permission to the King by His Majesty's dutiful Subject and Servant John Nash*. The large majority of the plates were based on watercolours by Augustus Charles Pugin (father of the more celebrated architect, A. N. W. Pugin), a Frenchman who came to England to escape the Revolution and who had first been engaged as a draughtsman by Nash in the early 1790s.

According to Pugin's pupil and biographer, Benjamin Ferrey,

"the King's object was to have an elegant book which he might give as a souvenir to those who were honoured by invitations to Brighton. The strictest precautions were therefore taken to prevent the possibility of any of the impressions of the plates becoming public; but it was hardly to be supposed that in the passage of the copper-plates and proofs through the hands of the engravers, printers, colourists, and others, some stray prints might not be dispersed."

Ferrey goes on to relate how some were indeed sold with the effects of an engraver who had gone bankrupt, but that they were bought and returned by a friendly bookseller, who narrowly escaped being

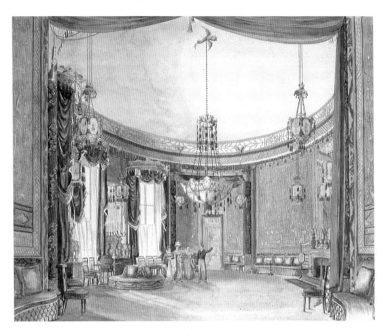

THE SALOON
(from a watercolour by A. C. Pugin of c.1820)

prosecuted at Nash's behest: "this fact shows with what vigilance Mr. Nash carried out the King's command in connection with the preparation of this book, proof impressions of which were submitted to His Majesty and revised by the King's own hands."

Against this account, the outline etchings that exist for almost every view, and that were bound into the book with the relevant coloured aquatints, are each inscribed "published by J. Nash and sold by R. Ackermann, 101 Strand", with dates ranging from 1820 to 1825. This seems to prove that they could be bought individually by members of the public before the book itself had appeared, and suggests that Ferrey was referring to the coloured aquatints only. In that case, Nash was almost certainly engaged in a private speculation, though with the King's agreement to purchase a certain number of copies of the final work. This is also confirmed by the inclusion of the original plates in the sale following the architect's death in 1835.

Illustrated guide books to country houses were already common in the eighteenth century, not only for palaces like Stowe but also for more modest villas like Strawberry Hill. However, it was the improvement in printing techniques that led to more accurate line-engravings of interiors in the early nineteenth century: for instance, the views of Thomas Hope's rooms at Duchess Street, in his *Household Furniture and Interior Decoration* (1807); or Britton's *Historical Account of Corsham House* (1806), showing Nash's own gallery and staircases – an important influence on those at Brighton – engraved by J. P. Neale. The aquantint process, a French invention, also made accurate colour reproduction possible for the first time, providing a subtly shaded foundation, which could then be finished by hand, by impecunious artists, students – or even children, as in the case of Humphry Repton's *Theory and Practice of Landscape Gardening* (1803).

Nash's *Views of the Royal Pavilion* may partly have been inspired by Repton's own *Designs for the Pavillon* (1808), based on the 'Red Book', which he had (unsuccessfully) presented to the Prince two years earlier. But a still more powerful impetus was W. H. Pyne's

Royal Residences, which was first advertised in Ackermann's *Repository* in 1815, issued as single plates over the next few years, and finally published in three folio volumes in 1819. This magnificent work contained a hundred coloured plates (the majority after watercolours by Charles Wild), and covered Carlton House and Frogmore as well as the five official residences of the sovereign. Brighton was probably excluded only because it was then undergoing its final transformation according to Nash's designs, and this separate volume devoted to the building may initially have been regarded as an addendum to the previous series.

Unlike Pyne, who was bankrupted by the cost of the illustrations, and ended up in a debtors' prison, Nash appears to have made his publication pay. One of his ledgers, now in the library of the Royal Institute of British Architects, shows that he paid Pugin a total of £3,746. 8s. 6d. (including a 7½ per cent commission for superintending all the work on the illustrations) in December 1827. The book itself was retailed at twenty guineas a copy, and the King apparently paid full price for an initial 86 copies, bound in purple morocco and embossed with the royal arms. Another twelve were supplied to him in 1830, just before his death – so it is possible that he had agreed to take a hundred (the remaining two being Nash's gift to his royal patron). Rudolph Ackermann took a number of other copies, at the 25 per cent discount offered to the trade, and the ledger records a total sale of 173 books for £3,568.15s. Only another dozen on top of this would have put him into profit, and it is likely that many more were sold – while Nash would have been paid extra for the outline etchings sold separately through Ackermann's shop in the Strand.

The ledger also records the amounts paid for each view: 25 guineas for the majority, but 12 for some of the smaller ones, and 40 for the interior of the stables, the Saloon, the Banqueting Room and the Music Room. In the last two (pages 81 and 97), Pugin was assisted by James Stephanoff (author of many of the views in Pyne's *Royal Residences*), who contributed the figures – which were also separately engraved by James Agar. A preliminary pencil drawing for the

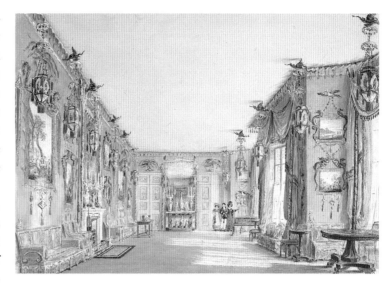

THE YELLOW DRAWING ROOM,
(from a watercolour by A. C. Pugin c.1820)

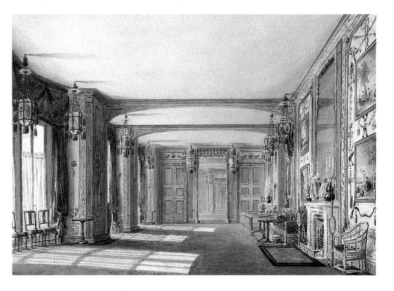

THE BLUE DRAWING ROOM,
(from a watercolour by A. C. Pugin made before 1824)

Banqueting Room (in the Royal Pavilion collection) shows not only the dinner guests and servants added in watercolour, but also the Chinese figures in the surrounding wall-panels, presumably all in Stephanoff's hand. For the distant view of the West Front (page 41), Pugin called in a still more famous artist, Copley Fielding, to help with the landscape setting. Otherwise the views seem to have been entirely his own responsibility, apart from four by Charles Moore (pages 33, 53, 101, and 121) and one by John Willis (page 21). Six others are unsigned, however, (pages 17, 49 (top), 57, 69, 85, 113), and seven undated (pages 17, 49 (top), 61, 85, 125 (bottom), and between pages 8 and 9). The most expensive of all the plates was, not surprisingly, the section through the state apartments (between pages 8 and 9), for which Nash paid Pugin 50 guineas.

In addition to the coloured aquatints reproduced in this modern edition of Nash's *Views*, the original volume also contained three extra plates as outline etchings only: "The Saloon as it was", (based on the watercolour page 10), the pencil sketch for which is dated April 2nd, 1820; the "Yellow Drawing Room", later the Music Room Gallery (based on the watercolour page 11), bearing the same date; and the "Blue Drawing Room", later the Banqueting Room Gallery, by Pugin, engraved by T. Kearnan, and dated December 1st, 1824 (again after the watercolour on page 11). The only other etchings dated as early as 1820 are those of "The Gallery as it was" and the kitchen (pages 69 and 113) – also made in April of that year, and also unsigned.

Why these four views should have been made, a good three years before all the rest, remains something of a mystery. But it is possible that they represent a false start to the project, begun before the final phase of the Pavilion's decoration. When the rest of the series was made, between June 1823 and April 1825 according to the dates of publication on the outlines, the view of the kitchen was retained because it had hardly changed (apart from the addition of the palm-tree capitals to the columns – duly recorded in the aquatint); while the other three views were presumably kept because Nash and his patron thought it of interest to compare the earlier and later states of these rooms. The outline of the Banqueting Room Gallery as it had originally looked would then have been added for the sake of consistency.

A volume containing most of Pugin's pencil and watercolour drawings for the *Views* was purchased by the Corporation of Brighton in 1923, and the majority are illustrated in John Morley's *The Making of the Royal Pavilion, Brighton* (1984) – together with two finished watercolours of the Saloon now in the Royal Library, Windsor. None of these drawings is dated, however. In the Royal Archives, there is also an undated manuscript in Nash's hand, which was evidently intended as a draft commentary to be printed with the *Views*, but which for some reason was never used. This apologia, somewhat defensive in tone, is quoted where relevant in the text accompanying the present plates, as is the longer and more detailed commentary written by E. W. Brayley for a new edition of the *Views* in 1838. This new book, entitled *Illustrations of Her Majesty's Palace at Brighton; formerly the Pavilion*, was published by J. B. Nichols, who had bought the plates after Nash's death, and consisted only of outline etchings and eight monochrome aquatints. However, replicas of the coloured plates were also made, separately "mounted, on cardpaper, as Drawings", though they could be "bound with the Work at the option of the purchaser".

This new edition of Nash's *Views*, published to celebrate the tenth anniversary of Pavilion Books, reproduces the complete series of aquatints in colour for the first time since that date. The titles adopted for each view generally follow those given in the table of contents of the original, though occasionally those on the outline etchings have been preferred for reasons of clarity. The Music Gallery and Banqueting Room Gallery have been used throughout the text in place of the North and South Drawing Rooms — names which were only introduced in the Victorian period. The order used is also the same as the original, apart from the Staircase (page 77), which is placed here after the two views of the Gallery, rather than after the Octagon Hall, where it was clearly out of sequence.

JOHN NASH
by Sir Thomas Lawrence
(Reproduced by kind permission of the Principal,
Fellows and Scholars of Jesus College, Oxford)

THE STEINE FRONT

PREVIOUS TO THE ALTERATIONS

The Steine Front previous to the alterations

DESPITE ITS TITLE, this plate illustrates two distinct stages in the development of the Pavilion, both of them masterminded by the Prince of Wales' first architect, Henry Holland.

The east elevation of the Prince's original 'Marine Villa' is shown above, as built in 1787, overlooking the Steine, an open area where the Brighton fishermen dried their nets, and with a sideways glimpse of the ocean beyond. The left-hand section, with its two bow windows, represents the full extent of the 'superior farmhouse', which his German cook and factotum, Louis Weltje, had leased the previous year. This contained the Prince's private apartments: a breakfast room and ante room on the ground floor, with a staircase between them; and a bedchamber and dressing room above. To the north of this, Holland added the rotunda containing the saloon (still at the centre of Nash's hugely enlarged front), and beyond that a wing matching the farmhouse, and containing an eating room and library. The taller French windows on the ground floor, and the reduced size of the bedchamber windows above, show that these two reception rooms were given higher ceilings, as befitted their use. Other early drawings show eight Coade stone statues placed over the columns of the rotunda, following Pierre Rousseau's Hotel de Salm in Paris – thought to have been Holland's inspiration – and external shutters to all the windows. Holland's favourite cream-glazed Hampshire tiles (already employed at Althorp in Northamptonshire) were also used to cover the old flintwork walls of the farm and the timber construction of the new wing, giving a sense of unity to the whole building.

The plan below shows the Pavilion as enlarged in 1801–1802, in Brayley's words, 'by the same architect, or rather by his pupil Mr. P. F. Robinson, F.S.A., who was stationed at the Pavilion, and during Mr. Holland's absence on some mining affairs in Cornwall, had the special direction of the works in progress'. These additions principally consisted of a new eating room and conservatory built out at an angle to the north and south respectively, and a new entrance hall created by moving the portico further out to the west. The ground-floor rooms of the original villa were also amalgamated to form two large galleries flanking the central saloon (the basis of the present Music Gallery and Banqueting Room) by 1815. The thin wings flanking the forecourt are part of the 1787 building, and housed guests and attendants, but the staircase and water-closets off the long spinal corridor are also additions of 1802–1804. The kitchen was in an already existing building, jutting out at an angle behind the north forecourt wing, and on the right can be seen the plan of another substantial earlier house, owned by the Dukes of Marlborough, and only acquired by the Prince in 1812. Repton's *Designs for the Pavilion* at *Brighton*, made in 1805, show this as a plain red brick Georgian block with a hipped roof, dwarfing Holland's villa in scale, and it was not to be demolished until Nash's transformation of the Pavilion, begun in 1815.

The stables, on the far left, were converted into household offices and servants' quarters after the building of William Porden's new stable block in 1804, and the large rectangular riding school projecting on the east was to become part of Nash's Great Kitchen.

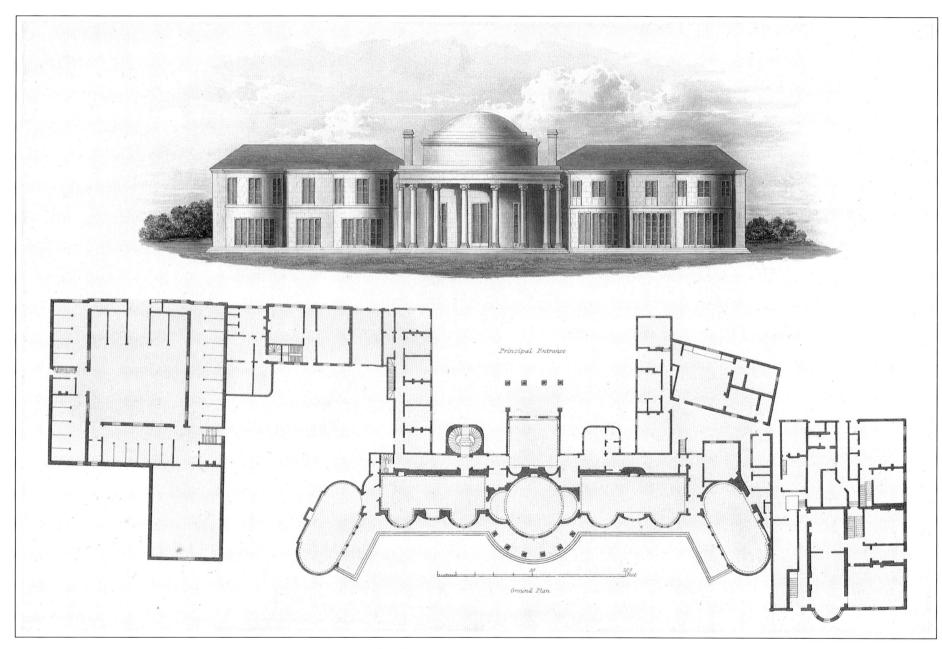

Principal Entrance

Ground Plan

THE STEINE FRONT PREVIOUS TO ALTERATIONS

The Steine Front

As Originally Designed

The Steine Front as originally designed

THE POINT AT WHICH the Prince Regent began to 'orientalize' the Brighton Pavilion is still a matter of debate. E. W. Brayley, who wrote the commentary to the 1838 edition of Nash's *Views*, put it at 1802, when a gift of 'very beautiful Chinese paper' persuaded him to amalgamate Holland's original eating room and library to the north of the rotonda, and create a 'Chinese Gallery' in their place. However, a drawing made in Holland's office the previous year, 1801 (probably by P. F. Robinson), already proposed decking out the whole exterior in the chinoiserie style, and this idea was developed still further in a series of designs by William Porden.

Ultimately, the catalyst for the transformation was Porden's huge new stable block in the Indian style, begun in 1803 to the north-west of the Pavilion, and dwarfing it in scale. Humphry Repton, called in to advise on the gardens in 1805, was thus encouraged to give his opinion "about the style of an entirely new house, which might best assimilate with the large dome of the Stables, already built." Having just worked at Sezincote in Gloucestershire, the remarkable Indian-style house built by a retired nabob, Sir Charles Cockerell, Repton agreed that "neither the Grecian nor the Gothic style" would be compatible "with what had so much the character of an Eastern building". At the same time, "the Turkish was objectionable, as being a corruption of the Grecian; the Moorish, as a bad model of the Gothic; the Egyptian was too cumbrous for the character of a villa; the Chinese too light and trifling for the outside, however it may be applied to the interior." The only solution was to turn to "the Architecture of Hindustan".

Repton's *Designs for the Pavillon*, published in 1808, are far more pedantic and archaeological than those that his erstwhile partner, John Nash, produced in 1815 – when funds finally became available. Yet the seeds are there: particularly the idea of a large onion dome in the centre, whose vertical thrust contrasts with the broader glazed dome of Porden's stables. In the event, Nash was to place this dome immediately above Holland's rotunda, rather than building a new two-storey hall behind it as Repton had suggested. This preliminary design, probably made early in 1815, shows Holland's classical colonnade in the centre already replaced by tall pillars of Indian form with *jalis*, or pierced stone trellis decoration, between them. But the two flanking wings of the 'marine villa' are only thinly disguised, with a lesser order of columns supporting the first-floor balconies, and ridge-tiles that are more Gothic than Indian in detail.

Nash's major additions were the two great square blocks at either end of the façade – the one on the left containing the Banqueting Room, and the one on the right the Music Room – replacing the much smaller oblique wings which Holland had added in 1801–1804. It is clear from the accounts that these huge rooms were completed up to roof level by the end of 1816, but an engraving of the following year shows that their onion domes had already been replaced by the concave 'tented' roofs seen in the illustrations on pages 29 and 33. On the other hand, they still lacked their verandahs and *jalis* at this stage, and no change had yet been made to Holland's original villa, oddly sandwiched between them.

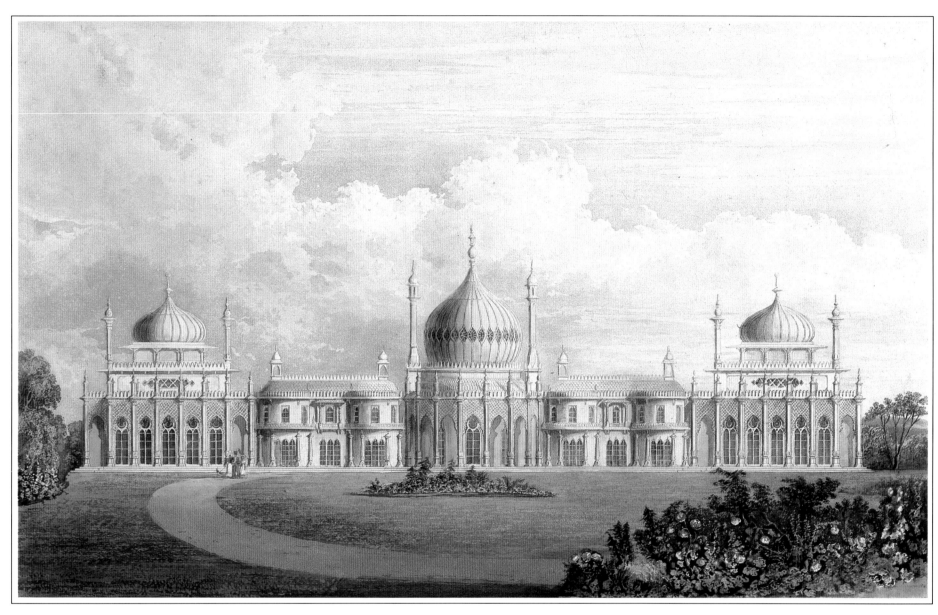

THE STEINE FRONT AS ORIGINALLY DESIGNED

GROUND PLAN

State Apartments.
1. Porch.
2. Octagon Entrance Hall.
3. Hall.
4. Gallery.
5. Banquetting Room.
6. Gallery to D.°
7. Salon.
8. Gallery to Music Room.
9. Music Room.
10. Red Drawing Room.

Private Apartments.
a. His Majestys Bed Room.
b. Anti Room.
c. Dressing Room.
d. Bath.
e.e. Libraries.

f. Anti Room.
g.g.g.g.g. Private Secretary's Apartments.
h.h.h.h.h. Visitors Apartments.

Private Apart.ts

i.i.i.i.i. Corridor.
k. Page's Room.
l. King's Kitchen.
m.m. Larders.
n.n. Kitchen for the Household.
o. Steaming Kitchen.
p.p. Pastry Rooms.
q. Tower for Water Reservoir.
r. Page's Dining Room.
s.s.s. Confectionery.
t.t.t.t. House Keeper, &c.
u. Open Court.

Offices.

Ground Plan

THIS HIGHLY DETAILED ground plan of the Pavilion, its outbuildings and grounds, shows the building as completed by Nash, in about 1821. The assembly room of the Castle Hotel was converted into a Chapel Royal as one of the finishing touches, completed in January 1822, so its description as a 'temporary chapel' here (top right) may indicate that the plan was drawn up a few months earlier.

The central part of the east front, looking over a wide lawn towards the Steine is recognizably that of Holland's original 'marine villa', though the wings flanking the rotunda have been slightly enlarged and only remnants of their four bow windows survive. Beyond them are Nash's gigantic Music and Banqueting Rooms. Holland's narrow spinal corridor has also been enlarged by Nash to form a long skylit gallery with staircases at either end, like his earlier gallery at Corsham Court in Wiltshire, dating from the 1790s. The way in which the Music and Banqueting Rooms are linked by two parallel enfilades is particularly skilful, and Nash's decision to lengthen the building so as to increase its apparent size is as successful inside as out.

The plan also shows Holland's forecourt almost entirely filled with new rooms, including an octagonal vestibule behind the *porte-cochère*, though his flanking service wings (one slightly longer than the other) can still be recognized. The King's new private apartments at the north-west corner are carefully screened off by planting, both from the main entrance on the west, and from the garden on the east. Nash had evidently learnt a great deal about landscape design during his brief partnership with Repton. His scheme at Brighton may well have been executed along the lines shown here, with the assistance of the royal gardener, W. T. Aiton, who was also involved with the architect at Buckingham Palace and St James's Park. The plants themselves would probably have been sent from Kew, where Aiton worked with Sir Joseph Banks, and would have included many exotics from India and China, as well as the Americas.

William Porden's stable block can be seen at bottom left, with the stalls radiating out from a central covered courtyard under the dome. The 'Unappropriated Ground', balancing the indoor riding school was originally intended as a tennis court, but was not completed until 1832 when it became 'Queen Adelaide's Stables'. It now houses Brighton's Museum and Art Gallery. Porden's stables were themselves converted into assembly rooms by the Corporation in 1867, and his rotonda was remodelled internally as a concert hall (known as The Dome) in 1934–35. The riding school, used in the Victorian period as a corn exchange, is now an exhibition hall.

Almost all the domestic offices to the south of the Great Kitchen have now been demolished, together with the flint wall separating the garden from the Steine, and affording the King and his guests some privacy. William IV replaced the two lodges with more substantial gatehouses in the Mogul style in 1831–32. The one on the north, apparently designed by Nash, still survives, but the one on the south, designed by Joseph Good, Clerk of Works to the Ordnance (who was also responsible for Queen Adelaide's Stables) was demolished later in the nineteenth century.

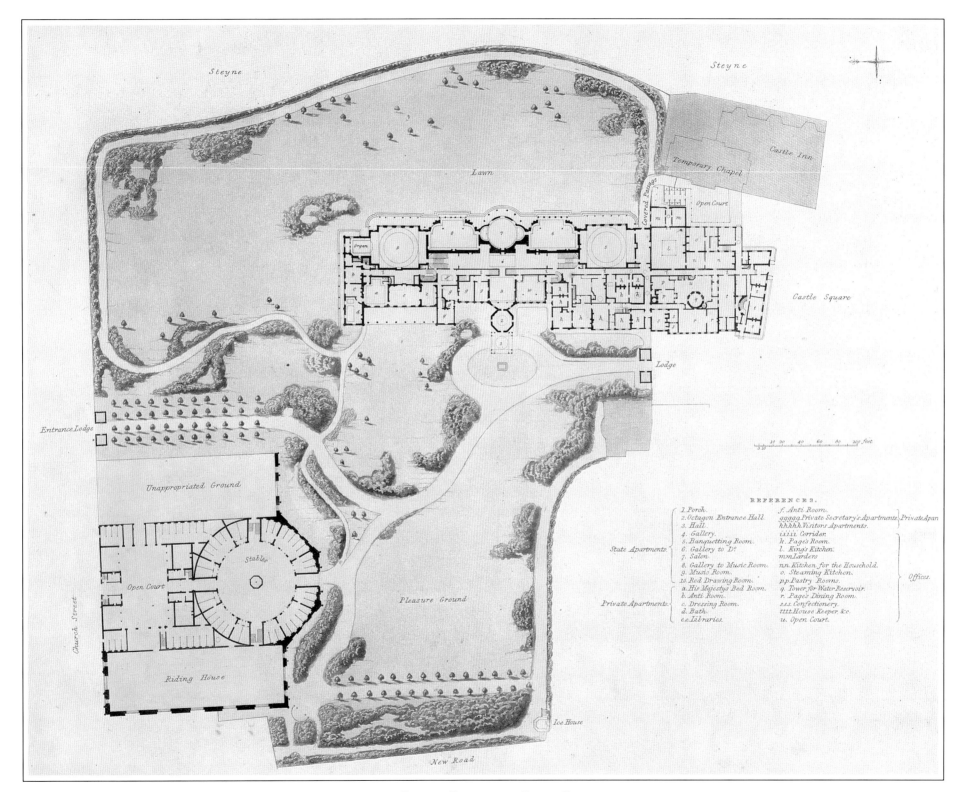

Steyne

Steyne

Castle Inn

Temporary Chapel

Open Court

Lawn

Castle Square

Organ

Lodge

Entrance Lodge

Unappropriated Ground

Open Court

Stables

Pleasure Ground

Riding House

Church Street

Ice House

New Road

REFERENCES.

1. Porch.
2. Octagon Entrance Hall.
3. Hall.
4. Gallery.
5. Banquetting Room.
6. Gallery to Do.
7. Salon.
8. Gallery to Music Room.
9. Music Room.
10. Red Drawing Room.
a. His Majesty's Bed Room.
b. Anti Room.
c. Dressing Room.
d. Bath.
e.e. Libraries.

State Apartments.

Private Apartments.

f. Anti Room.
gggggg. Private Secretary's Apartments.
hhhhhh. Visitors Apartments.
iiiiii. Corridor.
k. Page's Room.
l. King's Kitchen.
mm. Larders
nn. Kitchen for the Household.
o. Steaming Kitchen.
pp. Pastry Rooms.
q. Tower for Water Reservoir.
r. Page's Dining Room.
sss. Confectionery.
tttt. House Keeper &c.
u. Open Court.

Private Apartments.

Offices.

GROUND PLAN OF THE ROYAL PAVILION

GEOMETRICAL VIEW OF

THE STEINE FRONT

IN AN UNPUBLISHED preface to his *Views of the Royal Pavilion*, Nash observed that those who are "led to add to old houses . . . purpose to do but little, but they are led on from one desirable object to the other, till not infrequently it would have been cheaper and generally wiser to have rebuilt the whole." Despite this disclaimer, perhaps added to justify the enormous sums involved, the task of adapting Holland's existing villa in a manner which would complement, and hold its own against, Porden's Indian stable block, was a challenge that brought out all of his ingenuity and artistry.

Some historians have assumed that this elevation (showing the building as executed) and the so-called 'original' design (page 21), were drawn up at the same time – in 1815 – and offered by Nash as alternatives, leaving the Prince to choose the more expensive version. But despite Nash's own draft commentary on the *Views* "two designs were laid before H.M. . . .[and he] chose the latter"), it seems much more likely that the final solution was worked out during the course of the building work. The earliest and most important refinement, made in 1817, was the adoption of sweeping tent-roofs above the Music and Banqueting Rooms instead of the squat onion domes first proposed. More Chinese than Indian in inspiration, these look back to another 'pavilion': the twelve-sided ballroom that Nash designed for the Carlton House Victory Fête of 1814, and which still survives at Woolwich Arsenal. Their concave outlines, balancing the convex central dome, give an essential feeling of lightness and variety, stressing the vertical elements of what was basically a long, low building. The tall Islamic minarets also point heavenwards, though they are far too narrow for any muezzin to mount and call the faithful to prayer.

The final and perhaps the subtlest development of all was Nash's treatment of the low wings flanking the Saloon, only completed in 1820. Instead of simply altering their fenestration and applying Mogul columns, as he had first proposed, he crowned Holland's four bow windows with miniature versions of the great central dome, and then on the ground floor pulled forward the recessed centres between the bows to form straight screens, each with five floor-length windows separated by Indian pilasters. The wings thus became key elements in the whole composition, unifying the curving outline of the Saloon with the straight colonnades of the Banqueting and Music Rooms either side. Another important element in the success of the whole elevation are the recessed blocks at either end, yet again crowned by domes and minarets, although only the one on the right, incorporating a room for the organ leading off the Music Room, was actually executed.

In November, 1815, Nash is recorded as borrowing the four volumes of Thomas and William Daniell's *Oriental Scenery* from the library at Carlton House 'for making drawings of the Pavilion'. But, unlike Repton, he relied on their illustrations of genuine Indian buildings more for the handling of ornamental detail than for their architectural form. In the end, the east front of the Pavilion has a feeling of balance that is wholly classical, with its different sections tied together by two 'orders' of columns, and its skyline varied in the same manner as his domed Regent's Park terraces.

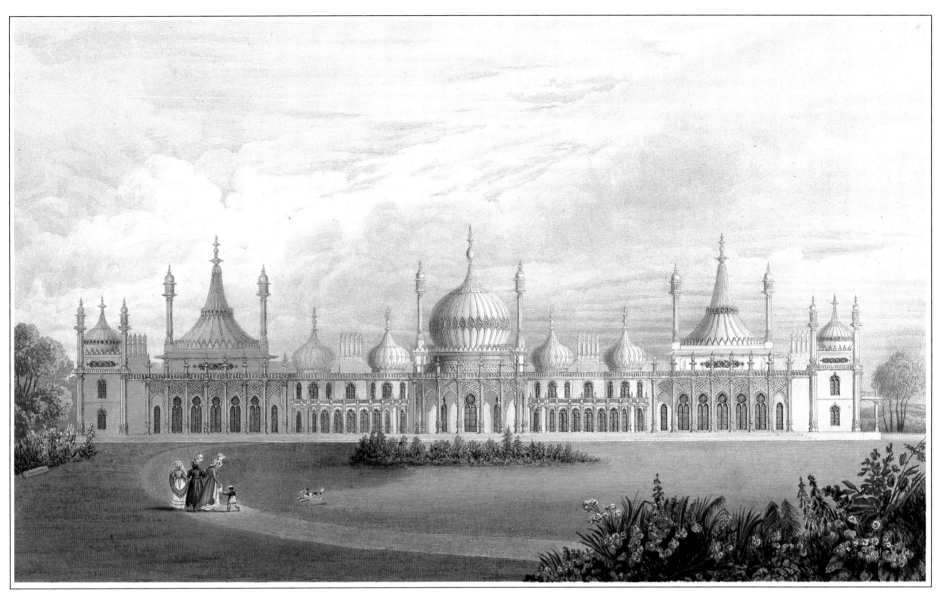

GEOMETRICAL VIEW OF THE STEINE FRONT

PERSPECTIVE VIEW OF
THE STEINE FRONT

Perspective View of the Steine Front

THE ROMANTIC AND picturesque qualities of Nash's Pavilion are best appreciated in this slightly angled view from the south-east, showing its forest of domes, minarets, pinnacles and chimneystacks silhouetted against a stormy sky. Strongly influenced by theorists of the Picturesque like Uvedale Price and Richard Payne Knight, whom he had encountered while working in Wales in the late 1780s, Nash was always more interested in a building's appearance within a landscape setting than as an isolated architectural statement. So, while the flattened elevation may give a clearer picture of its grammar, the perspective does full justice to its poetry: the advance and recession of the different elements; the play of light and shade; above all, that mixture of the humorous and the heroic that recalls the work of Lord Byron.

One of the key elements here is the perforated stone screen, based on the Indian *jali*, intended to provide shade and ventilation in the tropical heat, and used here between the giant columns masking the Saloon, Music Room and Banqueting Room. These impart a sense of mystery, wrapped like a lacy veil round the three main elements of the façade, and representing a perfect marriage between the classical portico and the oriental verandah. Both these and the subsidiary screens belonging to the Music Gallery and Banqueting Room Gallery, with similarly pierced parapets, were constructed of Bath stone, while the rest of the walls were covered in stucco.

The whiteness of the building, accentuated by the thunderclouds behind, may have intentionally recalled the creamy marble of Indian shrines like the Taj Mahal. But it is slightly misleading, for other aquatints in the series show that the stucco on the walls, and the mastic used to cover the domes, was painted to match the yellower Bath stone, so that the whole building was in the same tone. As early as 1802–1804, during Holland's alterations to the original villa, the scene-painter Louis Barzago was employed to paint the external stucco in variegated washes to resemble stone blocks, and this practice was continued by Nash.

The 'Dehl Mastic' – a mixture of litharge, pulverized stone, sand and linseed oil – which was used to cover the iron-sheeted domes and tent-roofs (and to model many of their ornaments) was a technical innovation that did not entirely pay off. In 1822, Nash received a stern reprimand from the King's secretary, Sir William Knighton, complaining that "the covering of the Magnificent dining Room, the interior of which has cost so large a Sum, is now in that state, that to secure it from Injury Pans are obliged to be placed over the Surface, to guard the Interior from the Influence of the Rain." It evidently continued to give trouble, for in 1827 the Banqueting and Music Room roofs and the central dome were re-covered in copper, whose pale green colour significantly altered the uniform tonality of the building depicted here.

The island beds and serpentine path shown in the foreground of Augustus Pugin's drawing are very much in the manner of Repton's 'Red Books', though they do not exactly match up with the planting shown on the ground plan (page 25). Whether accurate or not, the brilliant colours of the flowers, and the figures of the gardener and promenading guests, are reminders that the Pavilion was seen very much as a garden building for summer occupancy, with no less than thirty-one pairs of French windows or floor-length sashes on this façade alone, leading straight out of the state rooms onto the wide stone terrace. The glimpse of open countryside on the far right must be put down to artist's licence, however, for a number of earlier houses on the north side of Church Street would have blocked this view.

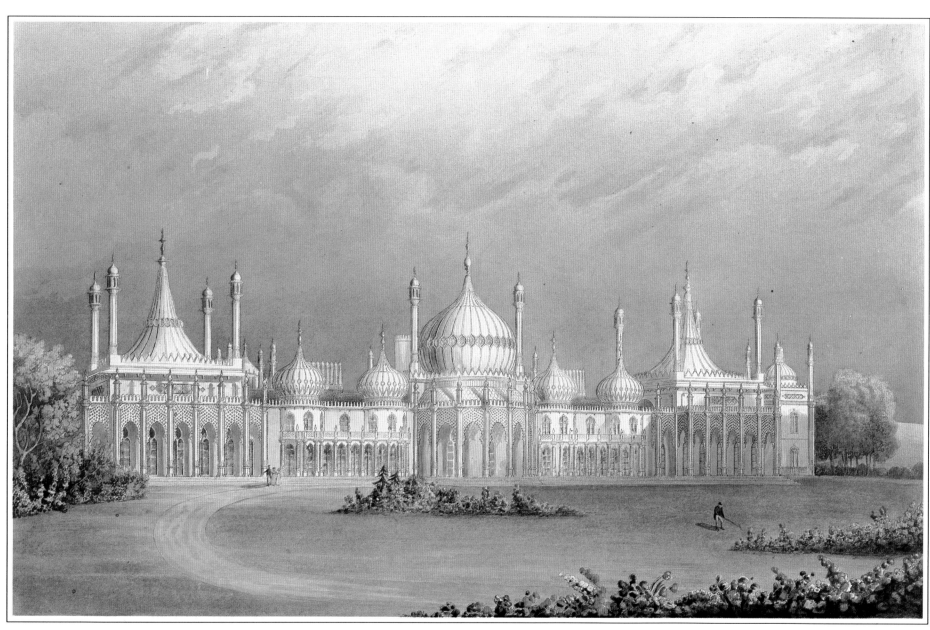

Perspective View of the Steine Front

CENTRE PART OF

THE STEINE FRONT

Centre Part of the Steine Front

IN AUGUST, 1818, the Prince of Wales made a special visit to Brighton with "several eminent architects" to witness the most spectacular episode in Nash's transformation of the Pavilion: the erection of the great dome over the Saloon, by means of a super-imposed cast-iron framework, built round the outside of the existing room like a huge metal cage. Always interested in the latest techno-logy, Nash had been much impressed by Bélanger's use of cast-iron ribs, when reconstructing the fire-damaged Halle au Blé in Paris in 1811 – a building that he inspected on his visit to France three years later. The Prince's wish to preserve Holland's Saloon intact, at the centre of the east front, presented a similar challenge. In the event, the frame was strong enough to support three rooms within the dome – an oval billiard room, and two bedchambers – each with a fireplace and hearth supported on special metal plates. Cast-iron was also used for the covers of the two flanking minarets, which were covered with bitumen, and which then had large sections of stone slipped over them.

The highly ornamental treatment of the stucco – and mastic – surfaces had a practical reason, for neither material was easy to apply on large plain areas without cracks or uneven joints appearing. Hence, the roof of the Saloon arcade is fashioned like over-lapping leaves, and echoes the fish-scale slates on the adjoining roofs, while the feathered ribs on the upper part of the domes look rather like over-sized tassels. The pierced stone *jalis* of the arcade below are also close to contemporary textile patterns rather than more conventional archi-tectural ornament, recalling the netted fringes of bed and window curtains illustrated in Ackermann's *Repository*, or George Smith's *Designs for Household Furniture*. On close inspection they consist of unashamedly Gothic quatrefoils (like the pierced parapets above the drawing room windows), typical of Nash's eclectic approach.

Naturally, the Daniells' *Oriental Scenery* and William Hodges' *Select Views in India* were plundered for authentic Mogul detail, like the 'Indian' giant order that seems to derive from the Daniells' illustration of a hall at Allahabad – or the ribbed domes themselves, close to the seventeenth-century Pearl Mosque in Delhi. But the tracery of the drawing room windows looks more Perpendicular than Punjabi, while the chimneystacks, grouped together to contribute to the picturesque skyline, are positively Tudor in inspiration – recalling the column chimneys of Longleat and Burghley.

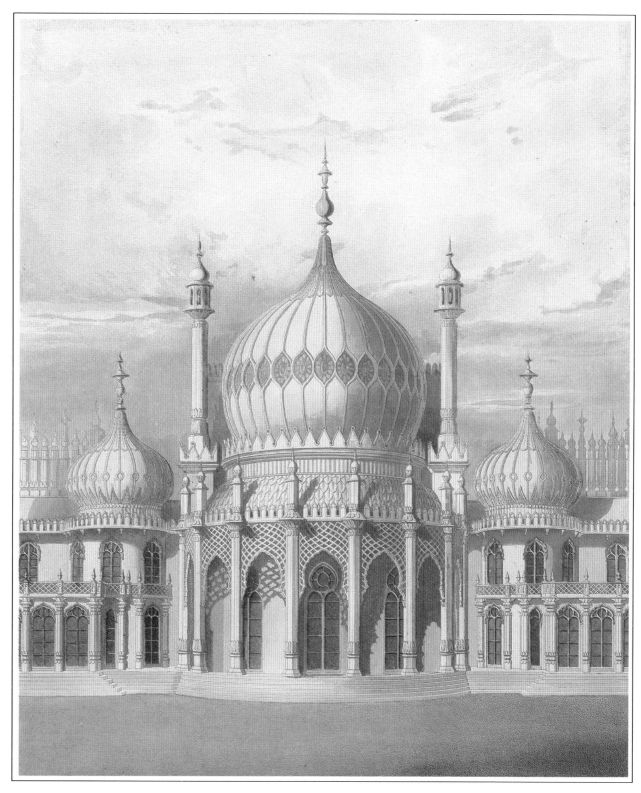

CENTRE PART OF THE STEINE FRONT

The West Front

The West Front

THOUGH NEVER CONSIDERED as important as the east front, which was clearly visible over the garden wall from the Steine – the most fashionable promenade in Brighton – the west front of the Pavilion was even more adversely affected by the proximity of Porden's gigantic stable block. Nash's task was to try to restore the balance between the two buildings, so that (in his own words): "the turban domes and lofty pinnacles might form their glittering and picturesque effect, attract and fix the attention of the Spectator, and the superior magnificence of the Dome of the Stables cease to be observed."

One way of doing this was to emphasize the building's length, keeping its overall width relatively narrow. This also had the advantage that the domes and minarets of the east front would be clearly seen rising above the parapets. So instead of following Repton's plan and making a grand new entrance front on the north, Nash stuck to Holland's original entrance, on axis with the Saloon. There were evidently a number of second thoughts about the best way to stress this central feature, for a hexagonal clock tower built here in 1816–17 was later dismantled, and the present *porte-cochère* was not completed until 1821. As it is, the build-up of domes, cubes and cylinders is as complex and as picturesque as anything in Nash's work.

The King's private apartments occupying the left-hand block, were also late additions of 1821, but their appearance here is somewhat misleading, for a dense plantation of trees and shrubs (shown on page 25) separated them from the more public area of the forecourt. The guest wing on the right was intended to be rebuilt as an exact match, but this was never achieved, and the façade remains asymmetrical to this day. On the far left can be seen the octagonal water tower that stood within the service courtyard to the south, dominating Castle Square beyond. This was sadly demolished in the late nineteenth century but can be seen in early photographs by Fox Talbot and others, and was an important element in the whole composition of the Pavilion, viewed from the west. All that now survives is its massive gilded weather vane, in the form of a dragon.

Though the landscaping may not be depicted entirely accurately, Pugin's preliminary sketches, obviously taken on the spot, show the kind of natural landscaping that Repton specifically advised against, when dealing with so small an acreage. For Repton, Nash's erstwhile partner, and a man whose plans had been so fulsomely praised by the Prince ("I will have every part of it carried into immediate execution. Not a tittle shall be altered – even you yourself shall not attempt any improvement . . .") it must have been a bitter pill to swallow.

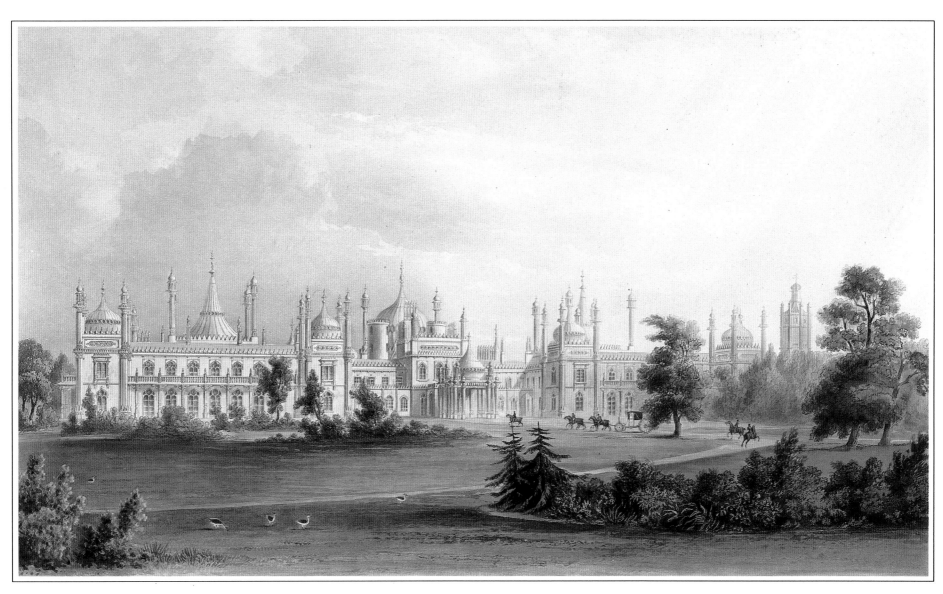

THE WEST FRONT

PRINCIPAL ENTRANCE

WEST FRONT

Principal Entrance, West Front

IN THIS CLOSE-UP view of the forecourt of the Pavilion, the painting of the stucco walls, designed to resemble Bath stone blocks, is particularly noticeable. All the ground-floor windows on the left, with their blue curtains, belonged to the King's private secretary, who could thus keep a close eye on the comings and goings of visitors. The four windows to the right of the *porte-cochère* belonged to the Red Drawing Room (page 65), which Nash built on the site of an earlier staircase, and which he extended westwards into the forecourt by the internal use of cast-iron pillars. The small arch in the right-hand corner was probably used by staff accompanying guests, who occupied the apartments in this wing.

Gothic elements are even more noticeable here than on the east front. The horizontal windows lighting the attic bedrooms in the three towers have glazing bars formed of bands of quatrefoils, while the two round towers flanking the Saloon dome (one of them containing a spiral staircase to the rooms within it) seem to have strayed from Nash's own neo-Norman castle at East Cowes. The large chimneystack between them, pierced by a window (a typical Nash joke), is also supported by strange flying buttresses, curved and also crocketed, set too low to be seen in this view, but just visible in the view on page 41.

The globular ornaments, like miniature onion domes, along all the parapets here and on the north front, might seem equally eccentric, though they derive from unimpeachable Indian sources like the view of the Pillibead Mosque in the Daniells' *Oriental Scenery* – whence Nash may also have derived his tapering, faceted column shafts, with their lotus-leaf bases.

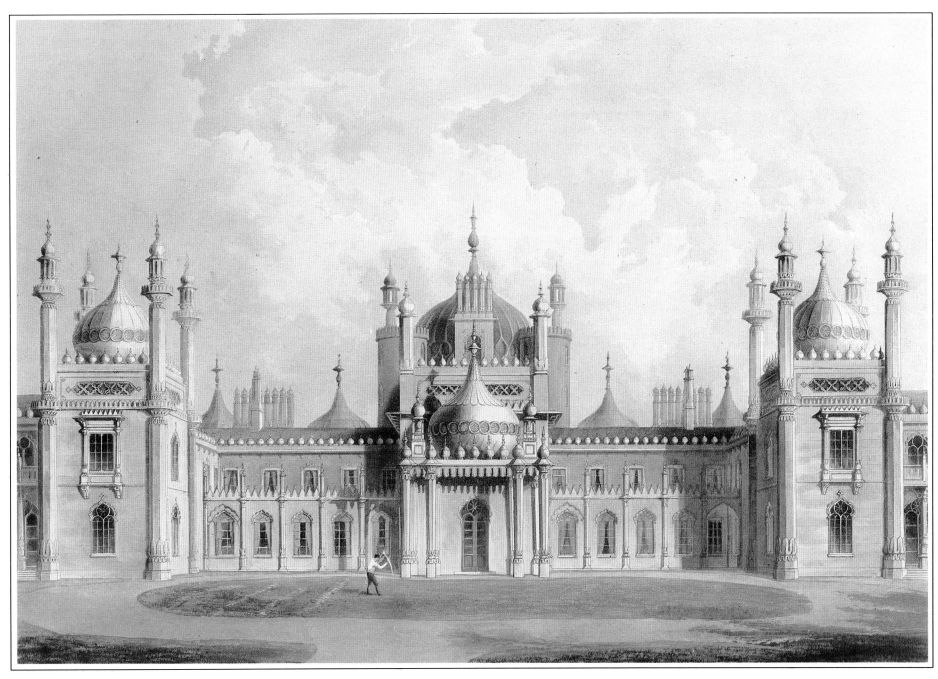

THE PRINCIPAL ENTRANCE, WEST FRONT

The Principal Entrance

AND

The North Front

The Principal Entrance and The North Front

THIS RATHER CURIOUS view of the *porte-cochère* in the centre of the west front, isolated from the rest of the Pavilion as if it were a separate garden building, may originally have been intended for a title page or tailpiece in Nash's *Views* rather than an independent plate. Planned in very much the same way as the Gothic porches of his country houses, and wide enough for carriages to enter under cover, it is in fact one of the few features of the Pavilion to be derived from an actual Indian building: a temple on the Ganges illustrated in Colonel Forrest's *Picturesque Tour along the Rivers Ganges and Jumna*. As this book only appeared in 1824, about three years after the *porte-cochère* was built, Nash presumably had preliminary access to Forrest's material, and was not confined to published sources.

One innovation wholly owing to the architect is the ring of glazed oculus windows set in a guilloche pattern round the centre of the dome. These had the effect of lessening its apparent mass, and providing a halo of catherine-wheels above the visitor's head as he entered. Conversely, at night, the gas-burner within the dome lit them from behind, so that they appeared as a welcoming beacon shining brightly through the sea-mist.

The plate clearly depicts the King, wearing a blue coat with the Garter star, arriving at the Pavilion and being greeted by an equerry, while a footman in pink livery stands by the door. The idea of the domed pavilion acting both as a miniature version of the whole building, and at the same time as a canopy of state fit for a Mogul emperor's throne, would surely not have been lost on contemporaries.

THE SURPRISINGLY MODEST seven-bay façade of the Pavilion facing north is a reminder of the sacrifices Nash made in order to stress the length of the building, saving the pomp and swagger for the east front facing the Steine, and the entrance front on the west, facing Porden's stables. However, its small scale and intimate character were also perfectly suited to its function, for behind it lay some of the most private rooms in the Pavilion: the King's ante room, dressing room and bathroom on the ground floor; and further family apartments above. The railings seen here, running just inside the pillars of the projecting loggia, were evidently designed to keep the curious at bay: reminders of the notice that the Duke of Wellington was obliged to post at Stratfieldsaye, requesting members of the public not to peer through the windows.

In its ordered symmetry and elegance, the north front, added in 1819, attempts none of the fireworks of the two adjacent façades, and looks back to some of Nash's earlier commissions, like Hafod House in Cardiganshire, with the Gothic detail merely changed to Indian. On the other hand the aquatint is slightly misleading, for Pugin's original sketch (still at the Pavilion) shows the great tented roof of the Music Room and its four much taller minarets looming behind the left-hand dome, as well as a glimpse of its verandah on the far left. These were evidently omitted for the sake of clarity, as were the much thicker plantations each side, screening this part of the garden from the rest, and ensuring that the north front was never seen from an angle in conjunction with its more grandiose neighbours.

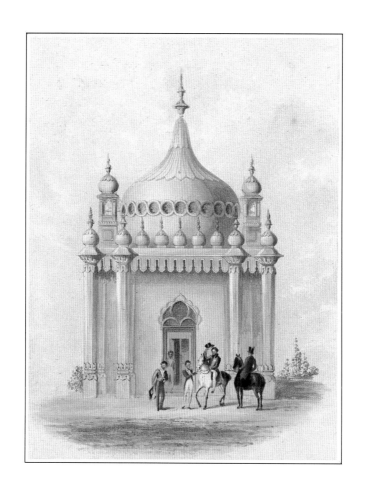

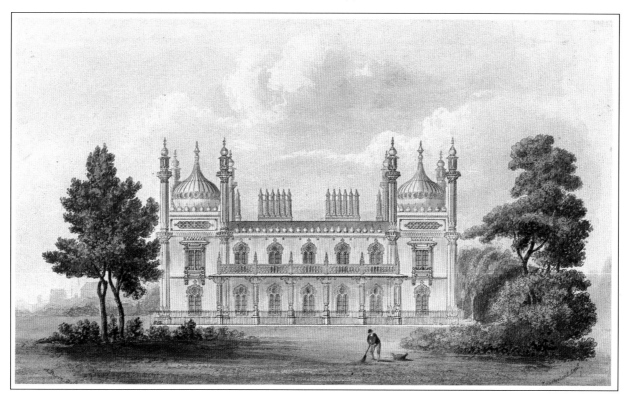

The Principal Entrance and The North Front

THE KING'S
PRIVATE APARTMENTS

The King's Private Apartments

THE MAIN SUITE of rooms occupied by George IV lay just round the corner from the north front, facing west. This wing was thus technically part of the entrance front, though in practice screened from the forecourt on the right by a thick plantation of trees and shrubs. The aquatint (one of the rare examples by Charles Moore, rather than by Augustus Pugin) once again omits this screen, so as to give a clearer picture of the architecture. The King's bathroom lay on the ground floor of the left-hand pavilion, while his bedroom was lit by the next two windows set back behind the loggia. The five remaining windows in this recessed section belonged to the two libraries which the King used as his private sitting room and study, while the right-hand pavilion was occupied by his private secretary. The apartments on the first floor were used by ladies of the family, including Queen Adelaide after 1830. Net curtains are hung in all the windows behind the loggia, once again to afford the sovereign some privacy while he made his elaborate *toilette*, or read his despatches.

Architecturally, the façade repeats all the elements seen on the north front, though with the loggia recessed between the two towers instead of projecting outwards. The pillars and brackets supporting the balustrade are probably based on the "Palace in the Fort of Allahabad" illustrated in the Daniell brothers' *Oriental Scenery*, while the 'tabernacle' surrounds of the windows on the first floor can be compared with their aquatints of buildings at Faizabad. Nash must have kept the middle section of this wing deliberately low so that the tented roof of the Music Room would appear above, and the success of the composition is largely due to its presence, hovering like a canopy over the otherwise unstressed centre. An identical façade was planned, but never executed, for the guest wing to the right of the forecourt.

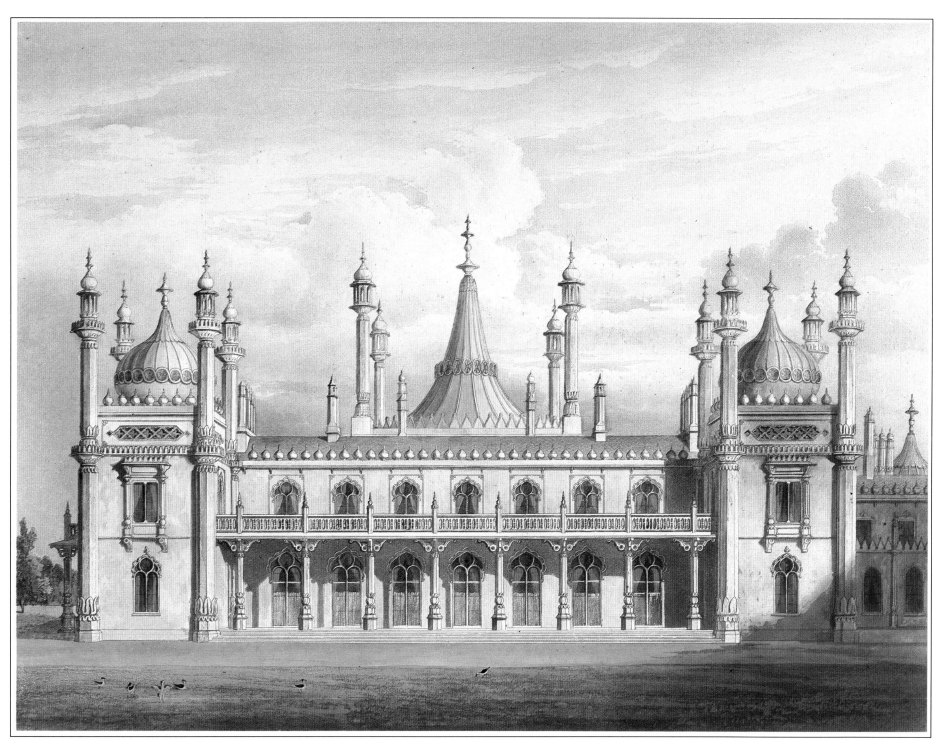

THE KING'S PRIVATE APARTMENTS

THE OCTAGON HALL

The Octagon Hall

IN HOLLAND'S ORIGINAL 'Marine Villa', the entrance portico backed straight onto the domed saloon, with doors at the sides leading into the corridors behind the other main rooms. In 1803–1804, when private parties were beginning to be more fashionable than the old public assemblies, a square hall was built in its place and the portico moved outwards. Nash in turn moved the hall still further west so as to make room for his great spinal corridor or gallery behind, building rooms on each side which practically filled Holland's forecourt. But, in such a comparatively thin building, it was still a problem to create a long enough ceremonial entry on this east-west axis. So his solution was to build a one-storeyed extension beyond the main hall, containing an octagonal vestibule, projecting even further west than the flanking wings, and approached through the *porte-cochère* which straddled the drive.

This is the view that would have greeted visitors to the Pavilion as the footman ushered them through the glass doors seen on page 49 (*top*). Like the *porte-cochère* itself, the octagon has the air of an insubstantial garden building, a charming *pavillon* in its own right, with a 'tented' plaster roof, wall panels framed by rope-mouldings, and floor-length windows giving views over lawns and flower-beds. Nash may purposely have arranged this visual pun as a way of announcing the character of the whole house: not a royal palace, but a private *trianon*, built for summer pleasures, far from the stiff etiquette of London and the court.

The chinoiserie theme of much of the interior is also announced here for the first time, as the front door opens, and the bells hung from the ceiling canopy tinkle in the breeze. Neither the architect nor his patron seem to have found any incongruity between the Indian façades, and the predominantly Chinese rooms behind them. This had, after all, been a feature of the Pavilion ever since the creation of the Chinese Gallery (now the Music Room Gallery) in 1803–1804, when the exterior was still rigorously Neo-Classical. The style had held a fascination for George IV since his earliest years, many of them spent within sight of Chambers' pagoda at Kew, and among his mother's collection of mandarin figures and painted mirrors, porcelain garnitures and silk embroideries. Lord Macartney's celebrated embassy to the Emperor Ch'ien Lung in 1794 revived this interest (though the famous Chinese Drawing Room at Carlton House had already been completed four years earlier). Though on a much humbler scale, the Octagon Hall at Brighton may be a light-hearted, and less formal, reference to the domed tent in the Imperial summer garden where the ambassador's first audience took place.

The feeling of informality is enhanced by the polished brass chimneypiece, placed off-centre, and the strangely random arrangement of the furniture: two imported Chinese armchairs, three shield-backed English chairs belonging to the set in the main hall beyond, and a sidetable wedged up against the north window. The inkstand placed on this table would have been used by guests signing the book, or leaving visiting cards, while the Argand lamp on the chimneypiece (an oil-burner giving a stronger light than the earlier colza-oil models) supplemented the dim glow of the Chinese lantern, and could also have been taken outside by the footman to guide the steps of those arriving after dark.

The walls appear to have been painted a soft grey-pink, with grained window and door surrounds, while the floor was covered with a marbled oilcloth – an ancestor of linoleum – with mats to prevent wear in particularly vulnerable spots. The glazed French doors leading to the main entrance hall are shown open, together with the double doors beyond – so that the chimneypiece seen in the far distance is the one in the Gallery (shown on the right on page 73).

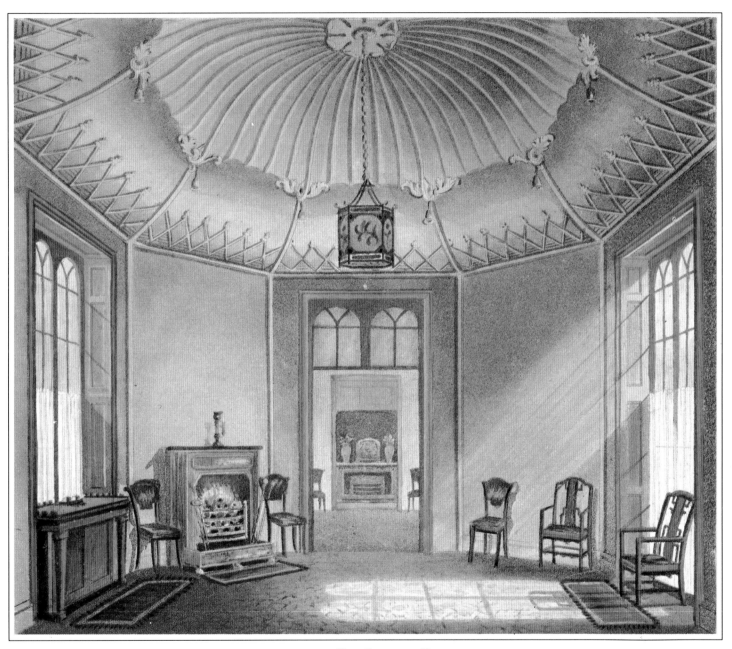

The Octagon Hall

THE ENTRANCE HALL

The Entrance Hall

THOUGH SOMETIMES ALSO called the 'Great Hall' to distinguish it from the little Octagon Hall preceding, this is another low-key prelude to the splendours that lie beyond. It was not always so. Henry Holland's (or perhaps more correctly, P. F. Robinson's) two-storey hall, with a gallery across the east end to connect the bedroom passages, was already flamboyantly decorated in the Chinese style as early as 1802, with a stove formed like a pagoda and life-size mandarin figures in niches. Nash incorporated part of this room, including the niches and mandarins, in the centre of his spinal Corridor or Gallery (see page 69), but decided that his new hall projecting westwards into the forecourt should be only one storey high, so as to allow two bedroom floors in the tower above it.

The lighting of the room presented problems, but Nash ingeniously overcame these by making a canted bay at the west end, with French windows looking out either side of the octagon. The west wall of the tower above was then supported on sturdy cast-iron pillars of Mogul form, while a clerestory of glass windows, painted with dragons in green and yellow, brought in extra daylight. The miniature 'vault' of the plaster cornice is Gothic in inspiration, though with a veneer of Indian ornament, and also cleverly serves as a framework for these painted glass panels.

The accounts reveal many changes of mind between the creation of the room in 1815 and its final decoration in 1820. Nineteen elaborate painted panels by Robert Jones came and went, as did a scheme in pink and green marbling for which some ravishing designs by Frederick Crace survive. In the end, the "ornamental painting in shades of Green", possibly imitating jade rather than marble, was carried out by Crace's men on paper mounted on stretched canvas. The dragons in the roundels and hanging 'banners' continue the theme seen in the painted glass, and on the four hanging lanterns, while more dragons in polished brass can be seen supporting the iron grate or 'register stove'. The sky ceiling, painted here in 1815, was replaced in 1820 by the light green which Pugin depicts, with "rosettes in relief". But perhaps because of the black marks made by the lamps, a return was very soon made to an "azure sky, diversified by fleecy clouds" – as described by Brayley in 1838.

The white marble chimneypiece by Richard Westmacott is one of the few still to remain *in situ* at the Pavilion, though the clock and japanned vases, forming a very French-looking garniture, have long since gone. The sabre-leg hall chairs, covered in green leather, contribute to the restrained colour scheme of the room, set off by the doors and window frames grained in imitation of pollard oak. The handsome grand piano by Tomlinson (dated 1821, and now in a private collection) has a rosewood case with 'Boulle' inlay in brass. Its presence here suggests that a small band may have performed in the hall after dinner to entertain ladies who had retired to the adjacent Red Drawing Room (through the door on the far left), or on other occasions for those promenading in the Gallery, with the double doors on the west wall left open.

In Henry Holland's day, a hall would almost invariably have been given a stone or marble floor, so the grey wall-to-wall carpet, with its red and black border, reflects new standards of Regency comfort.

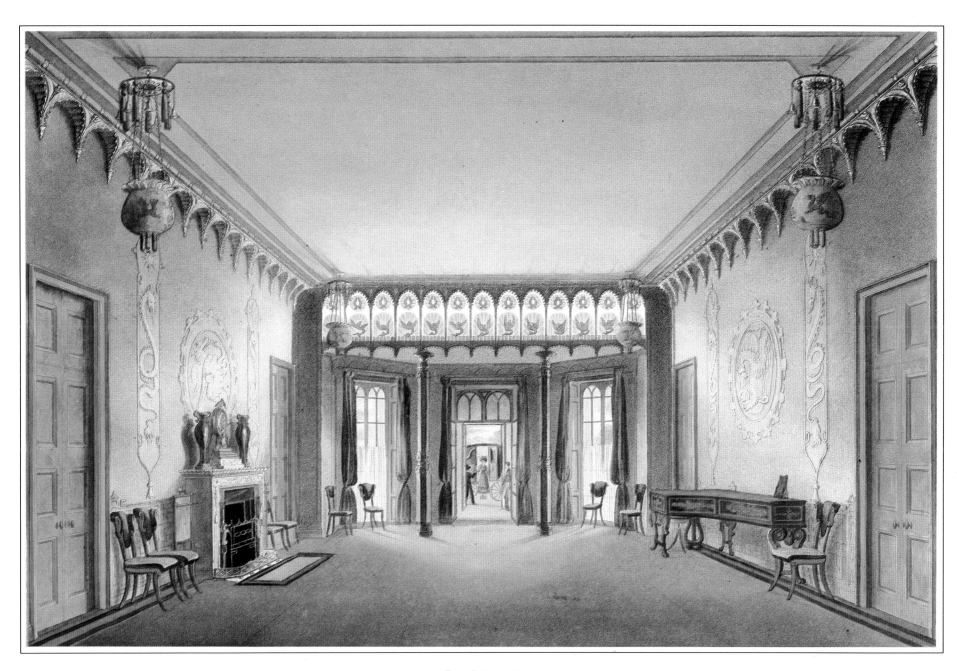

The Entrance Hall

THE RED DRAWING ROOM

The Red Drawing Room

IMMEDIATELY SOUTH of the hall, and overlooking the forecourt, this room also adjoined the guest apartments in the neighbouring wing. According to Brayley, it was generally used for breakfast (a meal which the King himself never attended), though other visitors recorded breakfasting in the galleries on the upper floor (see page 109). The account books also call it the 'Ladies' Drawing Room', so it is possible that it doubled up as a place for ladies to retire to after dessert in the Banqueting Room, and before re-joining the menfolk in the larger drawing rooms on the east front.

The cast-iron pillars in the centre were structurally crucial, supporting the recessed wall of the bedroom storey above (clearly visible in the view on page 45). But, as usual, Nash has made a virtue out of necessity, disguising them as bamboo trunks (curiously supplied with palm fronds at the top and lotus leaves at the bottom), and repeating them in pilaster form round the walls. The cornice, continued as the ribs of the compartmented ceiling, is more Gothic than Indian in feeling and can be attributed to Nash. However, the painted glass overdoors are genuinely Mogul in form, and are more likely to be by Robert Jones, who was commissioned to decorate the room (apparently independently of the Craces) immediately after his work on the Banqueting Room. The wall decoration, hardly visible in this view, repeats the idea of the silvered background to the panels there (page 97): a writhing mass of dragons, phoenixes and birds of paradise painted freehand in gold on a brilliant carmine red.

The 26 Cantonese export oil paintings – some in real, and some in *trompe l'oeil* bamboo frames – are the only framed pictures shown in the ground floor rooms in Nash's *Views of the Pavilion*, although similar series are seen in some of the first-floor bedrooms (see the section through the state apartments, between pages 8 and 9). Even here, they are used for purely decorative purposes (as in earlier eighteenth-century print rooms) rather than as serious works of art to study. The sofa in the draped alcove is of a type often known at the time as a 'sultane' (as in Nash's Sultana Room at Attingham, where Gillows of Lancaster fitted out a very similar recess). In this case the London upholsterers, Bailey and Saunders, supplied the striped green silk, also used for the window curtains and the continuous pelmet above them: a daring colour combination with the red walls, helped by the diamond-pattern fitted carpet in two different greens. A Brussels-weave carpet, this was probably manufactured at Axminster, like the more elaborate examples in the State Rooms on the east front.

The bamboo furniture here was probably bought in the early days of the Prince's chinoiserie craze, and relegated to this room when grander pieces were either purchased, or brought down to Brighton from Carlton House. However, the narrow ebony cabinet incorporating a lacquer panel looks French, and probably belongs to the last category. The large, gourd-shaped porcelain vases between the windows could be those shown in the earlier of the two views of the Gallery (page 69), adapted to hold candelabra at the time of their removal. Altogether, the Red Drawing Room preserved the light-hearted rococo attitude to chinoiserie, long after a weightier and more grandiloquent style had been established in the greater reception rooms on the other side of the Gallery.

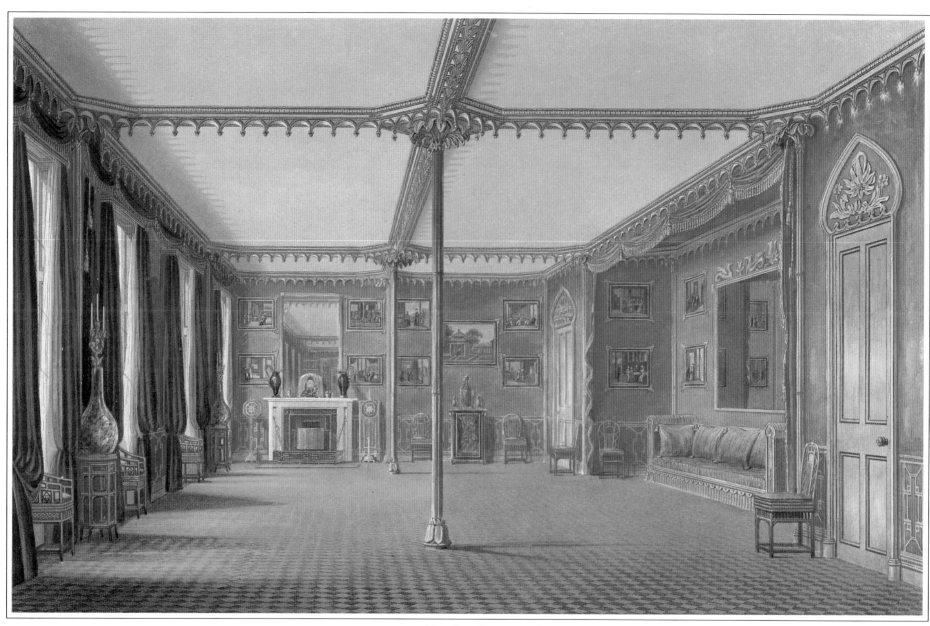

THE RED DRAWING ROOM

THE GALLERY

AS IT WAS

WHY NASH'S VIEWS contain two coloured aquatints of the Corridor, or Long Gallery – this one, published in 1820, showing it as completed in 1815, looking south; and another (page 73), published in 1824, showing it as redecorated two years earlier, looking north – remains something of an enigma. Perhaps Nash, or George IV himself, felt that both schemes were equally successful and worthy of commemoration. Whatever the reason, it demonstrates the importance they both attached to this key room, 162 feet long, sited at the very heart of the Pavilion, and its main thoroughfare. Nash's interest in the picturesque qualities of Elizabethan architecture had already encouraged him to experiment with the revival of the long gallery, for instance at Corsham Court in Wiltshire. At both Corsham and Brighton, his innovation was to provide dramatic light sources from above, and to incorporate staircases at either end, increasing the interest of the vistas in each direction.

Surprisingly, in a room that is so much Nash's creation, the deep niches flanking the chimneypiece are some of the oldest surviving features in the Pavilion. Originally placed in the back wall of Henry Holland's entrance portico, and clearly visible in his plans of 1787, they were then incorporated in the new entrance hall of 1801–1802, complete with the lifesize Chinese mandarin figures (clad in genuine robes) still visible in this aquatint. The central canopied area of the Gallery represents part of the old two-storey hall, with a new chimneypiece replacing the old pagoda stove, while the lower sections either side represent Holland's flanking corridors doubled in width by Nash.

The idea of an internal promenade must have prompted Frederick Crace's decoration, looking back to the famous bamboo groves of pleasure gardens like Vauxhall, similarly lit by Chinese lanterns, and with fretwork railings and little canopied pavilions. A fine linen stretched on canvas on the walls was thus painted with a continuous mural of waving bamboo fronds alive with birds, carried out in "a subdued tone of pale blue" on a "delicate peach blossom" background to suggest the magic half-light of dusk – or dawn.

The painted glass skylights cast the same dim glow by day as the Chinese lanterns by night. Among the strangest features were the tall supports for the lanterns down the sides of the Gallery: rather like Roman military standards hung with captured trophies, but here equipped with strange oriental weapons and talismans, carved by Fricker and Henderson. The bamboo theme of the walls was continued by the narrow trellises projecting from the walls and ceiling to demarcate the different sections of the gallery, and by the painted beechwood cabinets with panels of gathered red silk. These pieces of furniture were probably made by Elward, Marsh and Tatham for P. F. Robinson's 'Chinese Gallery' of 1803, and re-employed here by Crace in 1815. Even the latter's three chimneypieces are described in the accounts for that year as 'bamboo and marble' – the cast-iron elements once again painted to resemble split bamboo canes.

Princess Charlotte's companion, Lady Ilchester, writing in 1816, has left the best description of how the Gallery was used. Although the Queen was then staying with her son,

"the evenings were not in the least formal. As soon as [she] sat down to cards everybody moved about as they pleased, and made their own backgammon, chess or card party, but the walking up and down the gallery was the favourite lounge. All the rooms open into this beautiful gallery, which is terminated at each end by the lightest and prettiest Chinese staircases you can imagine, made of cast iron and bamboo, with glass doors beneath, which reflect the gay lanterns, etc. at each end. There are mandarins and pagodas in abundance, plenty of sofas, Japan and China."

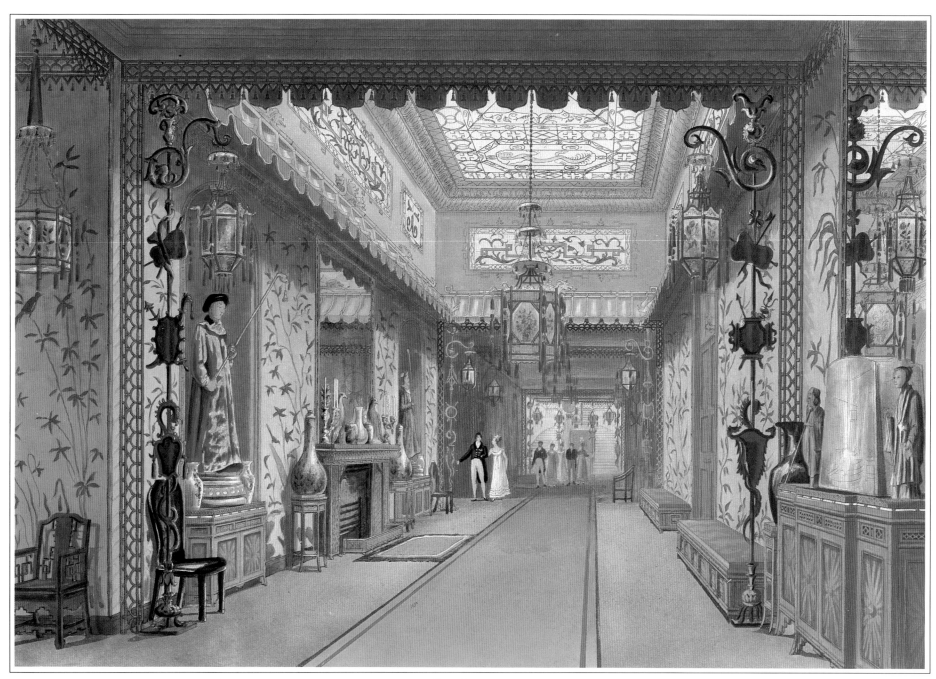

THE GALLERY AS IT WAS

THE GALLERY

AS IT NOW IS

The Gallery as it now is

THIS VIEW OF Nash's Gallery, looking north, shows its appearance after the modifications made in 1822, once again under the direction of Frederick Crace. On the left is the door to the Hall, and in the far distance, one of the mirrored doors to the Music Room. The Prince Regent had now become King, and after the riot of Chinese ornament seen on page 69, a certain gravitas and decorum has now been introduced. The bizarre Chinese 'standards' have been removed, and the lanterns now hang from the ceiling. Holland's niches have been filled with bookcases, and smaller mandarin figures now flank the fireplace, on stands inset with yellow-ground Spode china plaques. Apart from the Marsh and Tatham cabinets, all the rest of the flimsy bamboo and japanned furniture has been removed – some of it to the Red Drawing Room (page 65) – and replaced by a splendid set of Indian ivory-veneered chairs in the Chippendale style, which the Prince Regent bought at the sale of his mother's collection in 1819. These chairs had been bought for Queen Charlotte by George III, at the sale of the Governor of Madras, Alexander Lynch, in 1731. The two settees have up-to-date rosewood sofa-tables with brass galleries in front, in a bold mixture of dates and styles.

The large mirrors, placed opposite each of the principal doors so as to create transverse vistas, survived – and still do. The decorative scheme also remained much the same, apart from the introduction of greens in the surround to the central skylight and the painted panels below, large tinted glass screens dividing off the staircase areas at either end (somewhat marring Nash's open vistas through), and a wall-to-wall Brussels carpet with a busy geometrical pattern based on Turkish rugs, in place of the old green one, with its long red runner.

The central Chinese lantern was also replaced by a much larger painted glass chandelier bowl that had been made for the Saloon in 1815. At the same time, the cluttered arrangement of Chinese porcelain pots, birds and candelabra on the central chimneypiece, gave way to a more conventional garniture, with an ormolu clock in a glass case and a pair of large vases with *appliqué* ormolu candle-branches.

The lady shown searching for a volume in one of the bookcases, and the couple playing bezique or some other game at one of the sofa-tables give this the feeling of a comfortable living room rather than a mere passage or place for exercise.

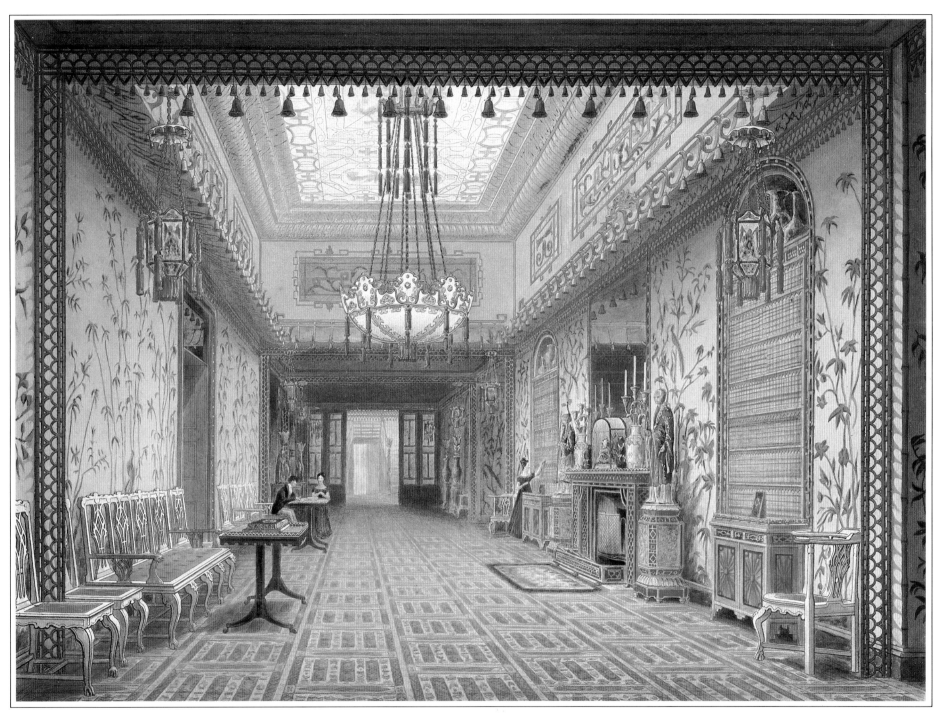

THE GALLERY AS IT NOW IS

THE STAIRCASE

The Staircase

THIS VIEW SHOWS one of the two identical staircases that Nash provided, one at either end of his central corridor or gallery, linking the Banqueting Room and Music Room. The double doors on the left led to the King's private apartments, and he himself appears to be the figure escorting two ladies from the Music Room straight ahead. The stairs and balustrades, which at first sight appear to be made of bamboo, are in fact of cast-iron, manufactured by William Stark, later to be one of Nash's tenants in Regent Street. They were hoisted into position in September 1815, and the decoration shown here was completed soon afterwards by Frederick Crace. Even the mahogany handrails are carefully carved with 'joints' and knots resembling genuine bamboo.

One of the two mirrored doors at the entrance to the Music Room is shown closed here, giving the impression that the stairs return in two more flights beyond. Many contemporaries admired this effect, and Brayley, in his commentary to the *Views*, described it as "an almost magical illusion, the perspective appearing interminable". The chairs, still in the Royal Collection, have early eighteenth-century Chinese backs, but English legs of the Regency period.

When the Gallery was redecorated in 1822, the standards supporting the lamps at the foot of the staircase were removed, and the plain carpet and runner were consequently replaced by a more elaborately patterned Brussels weave.

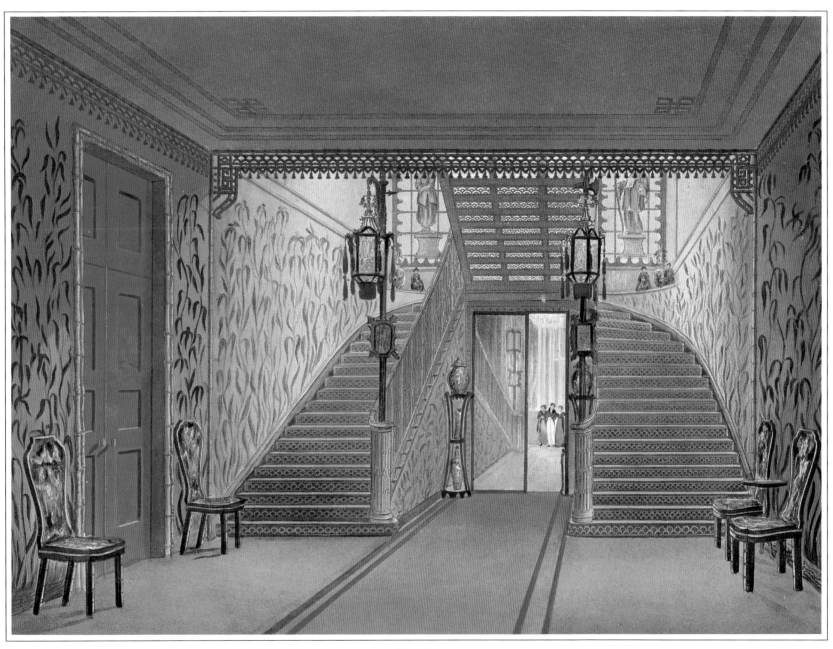

The Staircase

THE MUSIC ROOM

The Music Room

MUSIC WAS ONE of George IV's great passions. He played the cello, sang, and enjoyed nothing more than concerts, operas and military bands, seeing these not merely as diversions, but as an essential accompaniment to the pageant of a sovereign's existence. So it was no wonder that Nash's first major additions to the Pavilion were the vast box-like rooms at either end of Holland's villa – one devoted to music and the other to banqueting, his patron's other principal pleasure.

Though their sumptuous decoration makes them appear more complex, both rooms are quite simple in construction: domed square spaces with lateral extensions north and south. Neither the great beams forming an octagon over the central section, nor the eight arches that appear to carry the dome above the curious almond-shaped windows here, are actually load-bearing. The accounts make it clear that Nash, Frederick Crace and Robert Jones were all responsible for different elements of this magnificent stage set, and that their teams of men (thirty-four in Crace's alone) took nearly two years to execute the work from March 1818 to January 1820. In the end, they even had to labour by 'wax lights' at night to satisfy the Prince's characteristic impatience.

Crace's early designs in a light-hearted Chinese rococo style were rejected in favour of a much weightier, more dramatic scheme in "Carmine, Lake, Vermilion, Crome Yellow and other expensive colours", to quote Brayley. There is no doubt that these were primarily intended to be seen at night, when the great clerestory windows (recalling the all-seeing eye of the Buddha) were lit from behind, and when the famous water-lily chandeliers edged with 'pearls' like drops of water were illuminated by that new-fangled invention, gas – first installed here in 1821. The contemporary craze for panorama shows, with exotic lighting effects, was an obvious influence, and the stranger and more sinister elements of the room,

like Crace's winged dragons writhing in and out of the curtain pelmets, seem closer to the phantasmagorical imaginings of Coleridge and de Quincey than to earlier and politer visions of Cathay.

The organ, built by Lincoln, was the largest and most powerful instrument yet made in England, and Nash claimed to have controlled the acoustics of the room (and avoided an echo) "by some new theory of sound, which he endeavoured to explain" to J. W. Croker, "and which I did not understand, nor I believe he neither". As for the decoration, Robert Jones seems to have designed the remarkable marble and ormolu chimneypiece (made by Westmacott and Vulliamy and alone costing £1,684), as well as the Spode stands with gilt-bronze mounts, supporting the four huge vases from the Orléans collection, which stood in the corners, adapted as *torchères*. Most of the rest was designed by Crace, including the blue and gold Axminster carpet with Chinese symbols scattered over it, and the yellow silk curtains with their magnificient blue and red satin pelmets, made by Bailey and Saunders. A gifted French artist named Lambelet was apparently responsible for the exquisite wall panels in red and gold like huge sheets of lacquer, depicting scenes from Alexander's *Views of China*: perhaps the finest decorative painting to be found in the Pavilion today. The six great Oriental porcelain pagodas, four of them over 15 feet high, were also placed on pedestals made at the Spode factory and survive today at Buckingham Palace.

In this aquatint, the King is seen seated on the left between his current favourite, Lady Conyngham, and her daughter, while the couple on the far right appear to be the Duke and Duchess of Wellington. It is even possible that the conductor is Rossini, who paid a memorably successful visit to the Pavilion on 20th December, 1823, directing the members of the royal band in selections from many of his most celebrated operas.

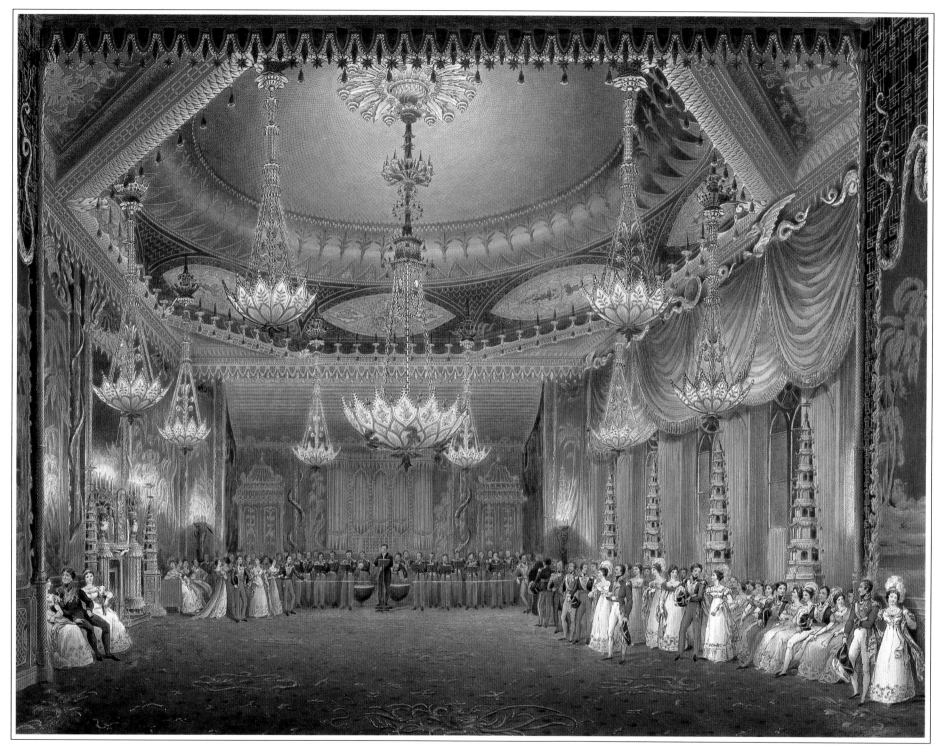

THE MUSIC ROOM

The Music Room Gallery

The Music Gallery

IN HOLLAND'S ORIGINAL villa, this space was occupied by the eating room and library, each with an east-facing bow window. However, in 1803, they were united to form one large room which was known as the Chinese Gallery, and used as a billiard room. After a short time as an 'Egyptian Gallery', it was then redecorated in the autumn of 1815 as the 'Yellow Drawing Room', reverting to a full-blown chinoiserie style – depicted by Pugin in an outline engraving at the end of the *Views*, dated 1820. The preparatory water-colour for this view is reproduced on page 11.

After all these vicissitudes, the room finally attained its present appearance in 1821, when Nash added the large rectangular projection to the east, inserting cast-iron columns (to support the walls above) at the point where each of Holland's truncated bow windows originally ended. In place of the earlier canary-yellow walls, inset with Chinese paintings in wildly exuberant frames, the King then introduced a much more refined decorative scheme – flake white walls with bands of gilt ornament forming tall panels, a wealth of mirrors, and striped yellow silk curtains and upholstery – as a setting for the Westmacott chimneypiece and some of the outstanding pieces of furniture originally in the Chinese Drawing Room at Carlton House. This remarkable building, which he was soon to demolish, was where his taste for the finest French and Oriental works of art first developed. The two were combined to memorable effect in the great garnitures of Chinese and Japanese porcelain with French gilt-bronze mounts, seen here on the chimneypiece and side tables – and in the two open cabinets of different form, made by Weisweiler in the Chinese taste. When these were transferred to Brighton, they were duplicated by Bailey and Saunders to form pairs, and placed at either end of the room and on the piers between the windows.

The canopied cornice was one of the only features of the old Yellow Drawing Room to be retained, though with bells substituted for the original painted tablets. Nash repeated this form at the top of his cast-iron pillars, but the gilt snakes entwined round their shafts were a tribute to the chairs and settees by François Hervé (also from Carlton House) with similar snakes wound round their legs. The two Boulle *bureaux mazarin* in the centre of the room were made by another French cabinet-maker working in London, Louis Le Gaigneur, and show that the King was (like his contemporary William Beckford) just as interested in the Louis Quatorze as in the Louis Seize style, and not afraid to mix the two.

The room must often have been used for chamber concerts and song recitals, when the numbers of guests did not justify using the great Music Room, glimpsed through the doorway at the far end. Hence the double row of chairs placed in the bay, and the large pianoforte in a rosewood case inlaid with brass, which is very similar to the one now on show, presented to the Pavilion by Queen Mary. Most of the rest of the furniture seen here is now at Buckingham Palace, apart from the set of four torchères between the windows of the bay: tall hexagonal shafts of Chinese porcelain with English ormolu candelabra and carved wooden bases, made specially for this position.

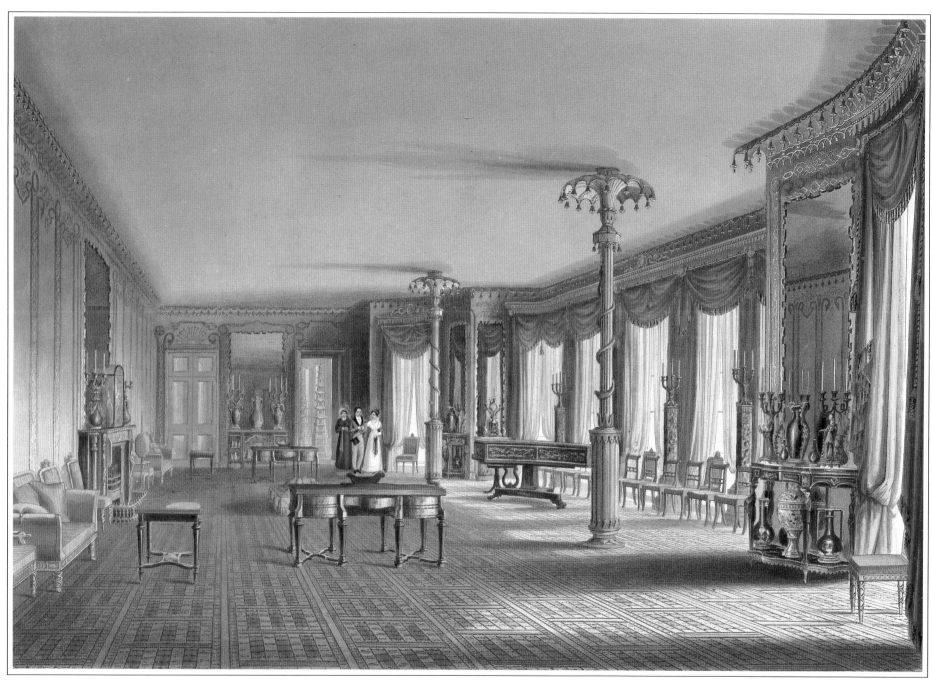

The Music Gallery

THE SALOON

The Saloon

THIS IS THE ONLY room in Henry Holland's 'marine villa' of 1787 that still retains its original form: a high rotonda at the centre of the east front, with semicircular apses leading to the Music Gallery and Banqueting Room Gallery each side. It nevertheless underwent as many facelifts as its neighbours in George IV's lifetime, and the decorative scheme shown here dates only from 1822–23, the very last period of activity before the Pavilion was officially declared complete.

To begin with, Holland's saloon (then the only large reception room in the house) was decorated with elegant Neo-classical wall-paintings by Biagio Rebecca. But in 1802–1804, it was remodelled to resembled a Chinese garden arbour, with a bamboo balustrade painted in *trompe l'oeil* above the cornice, and an open sky above, large panels of Chinese, painted wallpaper flanking the chimneypiece and in the apses, and a brilliantly festive colour scheme of blue, red and yellow. Alterations were made to this scheme in 1815, and the result commemorated in another outline engraving at the end of Nash's *Views*, dated 1820 (and based on the watercolour reproduced on page 10). But the decisive change came in 1822, when Robert Jones introduced a new note of regal splendour, returning to Indian ornament for his inspiration.

The frivolity and charm of the Chinese 'arbour' had largely depended on the variety of its colour and decoration. But Jones achieved his aim by opposite means, imposing a unity that the room had previously lacked. The colours seen here are almost entirely limited to gold, silver and crimson (those particularly associated with kingship), while the sunflower motif (probably derived from the famous 'Kylin' clock that once stood on the mantelpiece) recurs throughout, recalling one of Louis XIV's favourite symbols. It can be seen in the great gilded canopies that surmount the wall-panels,

overmantel mirror and curtains, derived from Mogul architecture; in the ornaments above the entrance to each apse; in the magnificent Axminster carpet; in the vast crystal chandelier supplied by Perry & Co., replacing the painted glass 'fish bowl' which was removed to the Gallery (page 73); and in the set of chairs by Bailey and Saunders standing in the window bays.

Jones also designed a set of white and gold open cabinets for the room, with still more prominent sunflowers, and with central niches repeating those on the marble and ormolu chimneypiece. But these cabinets were evidently not completed when Pugin came to make his drawing. Two of them are just visible between the windows in the cross-section (between pages 8 and 9), but the largest pair were soon to displace the banquettes on either side of the fireplace. In the 1850s, they were taken to Buckingham Palace by Queen Victoria, but have now been returned to Brighton on loan from the Royal Collection.

Only one touch of real fantasy was allowed to remain from the earlier chinoiserie scheme: the flying dragon painted in the centre of the ceiling, which Jones much enlarged, adding the coiling snakes that restrain it. The sun's rays behind are echoed in the central section of the carpet, once again helping to unify the decoration of the room. Pugin's original watercolour for this view shows the large wall-panels filled with a red and gold patterned silk stretched flat. The gathered treatment shown in the aquatint may be an afterthought, though for some curious reason the pattern still appears to show on the two panels in the far alcove. The six huge mirrors, supplied by Ashlin and Collins, are among the largest in the Pavilion, and add to the splendour of the King's principal reception room — a room once devoted to private pleasures, but now a worthy setting for the grandest of state occasions.

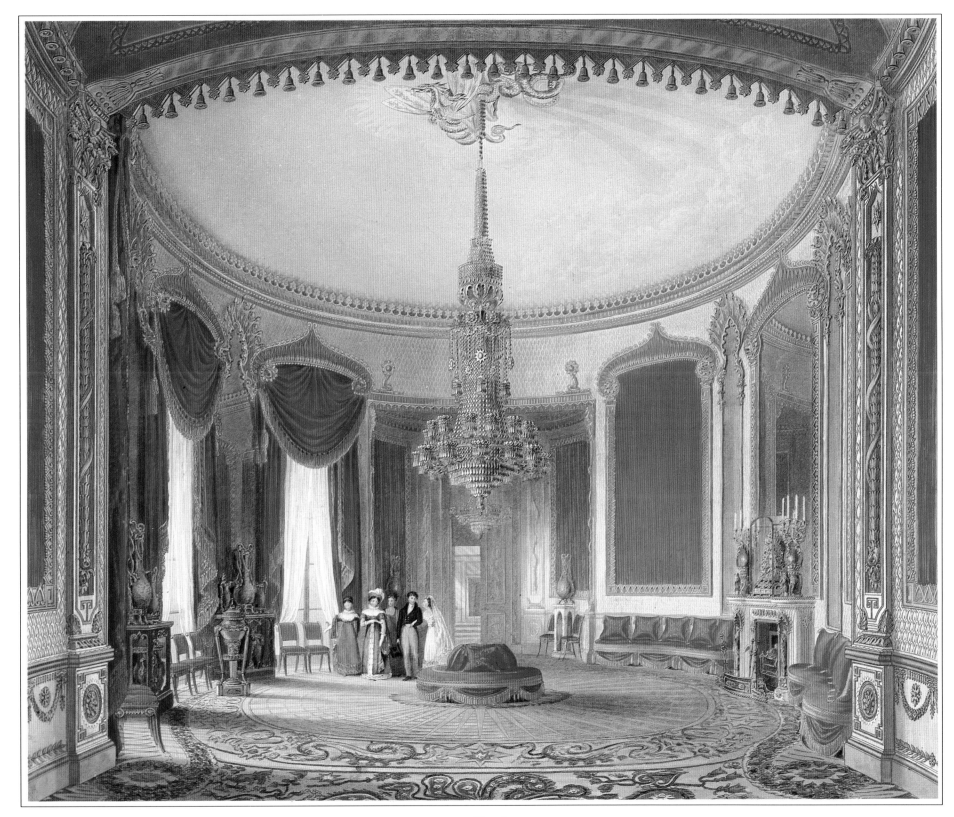

The Saloon

THE BANQUETING ROOM GALLERY

The Banqueting Room Gallery

IT IS ODD TO reflect that this room represents the whole width, and well over half the floor space, of the original farmhouse rented by the Prince of Wales in 1786 and subsequently enlarged by Henry Holland. But this also explains why its ceiling is noticeably lower than its opposite number, the Music Gallery – where Holland gained extra height for his new ground-floor rooms at the expense of his bedchambers above. To begin with, the modified farmhouse gave the Prince a private ante room and breakfast room, separated by a small staircase that led to his sleeping quarters. This stair was removed in 1802, but it was not until 1815 that the whole space was thrown into one. An early watercolour by Pugin (see page 11), again reproduced as an outline engraving at the end of Nash's *Views*, shows how it looked at that date, lit by Chinese lanterns, and with Chinese paintings mounted on the wall amid elaborate trophies. This form of decoration, perhaps derived from eighteenth-century print rooms, was not unlike the scheme in the old Yellow Drawing Room on the other side of the Saloon – although the colour here was blue.

The present appearance of the room dates from 1821, when it was enlarged by Nash along exactly the same lines as the Music Gallery (page 85), though with cast-iron pillars of a slightly different form, and a less elaborate cornice. The two white marble chimneypieces with ormolu bells and 'bobbin-reels' were allowed to remain, though the one on the right was moved to its present position for the sake of symmetry, and replaced by an alcove elegantly draped in green silk.

In many ways, the Music Gallery and Banqueting Room Gallery were now conceived as a pair. Their restrained white and gold decoration was deliberately low-key, both as a prelude to the fantastic opulence of the adjoining rooms, and as a setting for outstanding works of art brought from Carlton House. It is also interesting that they shared the same Brussels-weave carpet (following a Turkish pattern) that was used in the main Gallery or Corridor. In the eighteenth century, lacquer furniture was often thought appropriate for withdrawing rooms or dressing rooms where tea and coffee was taken, and that tradition can still be detected here, since the Banqueting Room Gallery was primarily a place for the company to retire after dining. The four magnificent Japanese lacquer cabinets seen here are thought to have stood in the library of Carlton House until 1815. At an earlier period, they might well have been raised on stands, but, like William Beckford, the Prince evidently preferred to use them like commodes, adding low feet and marble tops, to support garnitures of mounted porcelain. Other pieces from Carlton House include the sofas that match the Hervé suite in the Music Gallery Room; the gilt chairs with wreath and arrow backs – inaccurately depicted in the aquatint (a rare occurrence); and the four giant Chinese ewers standing on pedestals in the window bay.

The huge rectangular pier glasses make the window wall look as if it was almost entirely made of glass, and the multitude of mirrors help create the illusion of interminable, undefined space.

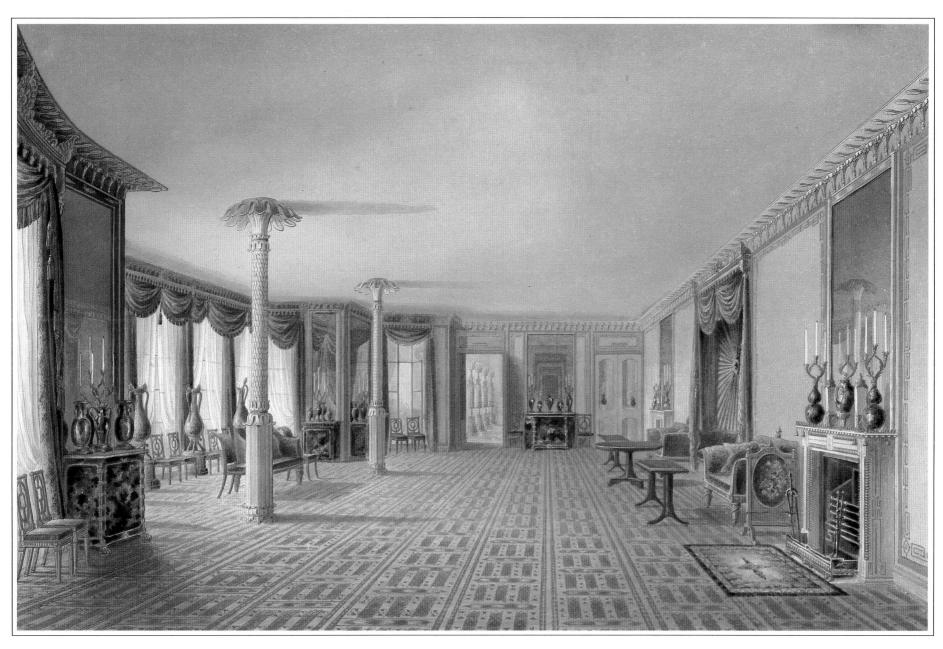

The Banqueting Room Gallery

THE BANQUETING ROOM

The Banqueting Room

APPROACHED EITHER FROM the South Drawing Room or from one end of the long, low-ceilinged Corridor, the scale and height of the Banqueting Room can overwhelm visitors today as it did in the Prince Regent's lifetime. "I do not believe," wrote Princess Lieven, who was used to the splendour of Imperial Russia, "that, since the days of Heliogabalus, there has been such magnificence and such luxury".

Like the equally monumental Music Room, at the other end of the corridor, the Banqueting Room occupies one of the great square blocks with 'tented' roofs that Nash first added, flanking Holland's original villa. Once again, the architecture is less complex than it appears, for the dome rests directly on the box-like structure below, and the flattened arches that appear to support it are mere stage scenery. The painted clerestory windows could again be illuminated from behind, like the ones in the Music Room, so as to give a jewel-like glow after dark. The surviving drawings and accounts suggest that the whole decorative scheme, saving the room from any feeling of banality, was the work of Robert Jones, and was his first important commission at the Pavilion, undertaken without the assistance of the Craces. Extraordinarily bold and imaginative, it must have amazed contemporaries and inspired visions of barbaric grandeur, beside which even the glories of Greece and Rome could seem prosaic.

The dome, painted as if open to a tropical sky, is almost filled by the leaves of a gigantic plantain tree (some in three-dimensional copper) against which a huge gilded dragon hovers. From its claws hangs a chandelier thirty feet high, a ton in weight, and (from December 1821) lit by that new marvel – gas. This confection alone cost over £5,600 – a sum which Princess Lieven's gossip happily doubled, though her informant may well have been including the four subsidiary lotus-leaf bowls, hung from similar mirrored stars, and borne aloft by four flying birds (representing the *F'eng* of Chinese mythology) attached to the pendentives of the dome.

The canopies over the two chimneypieces resemble great sagging sheets of gilded leather; the wall-panels, presumably painted by Jones himself, are in the manner of Boucher's earlier chinoiseries, set against a blue and silver ground of writhing dragons, birds, stars and waves, perhaps in imitation of incised mother-of-pearl; while the eight huge torchères with cylinders of Spode porcelain imitate Sèvres *bleu du roi* – with ormolu mounts once more in the shape of dragons. The "very large and superbly decorated Sideboards" that flank the chimneypieces and line the west wall were made by Bailey and Saunders "of very fine Rosewood, Snakewood and Satin Wood with 12 large Dragons and Ornamts. Richly carved and double Gilt in the very best manner to Mr. Jones' design". One of them has now been returned to the Pavilion on loan from the Royal Collection. The great Axminster carpet, made to cover the entire floor, has vanished, and the chimneypieces and overdoors, with some of the mural panels, are Victorian replacements. Otherwise the Banqueting Room remains remarkably unchanged.

Pugin's watercolour, which formed the basis for this aquatint, was made in or after 1820, and shows a typical dinner in progress, with the table laden with silver gilt, and set for dessert. The white biscuit figures in the centre are likely to be Sèvres, and the gilt-bronze pedestals and candelabra by Thomire, showing that the King's taste for French food was matched by his admiration for French works of art. He himself sits in the centre of the table facing the window, and the guest at the end nearest to the observer is not his brother, the Duke of Clarence (later William IV), as Brayley would have us believe, but – very easily recognizable – John Nash himself.

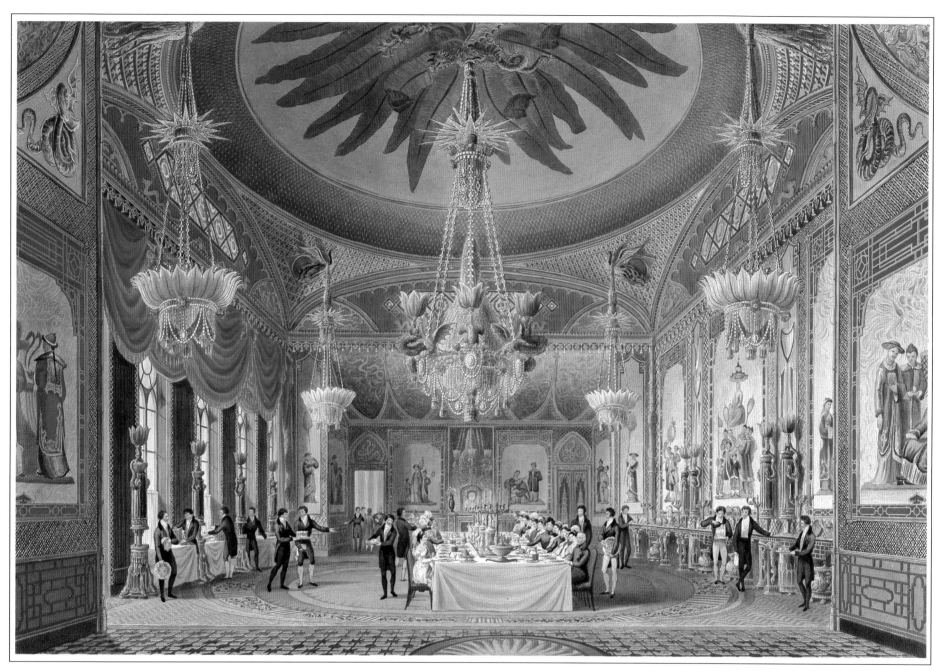

THE BANQUETING ROOM

THE KING'S BEDROOM

The King's Bedroom

AFTER THE FLAMBOYANCE of the great state rooms, the restraint and comparative simplicity of the King's private apartments comes as a surprise. To begin with, his bedchamber, dressing room and boudoir formed a suite above the Banqueting Room Gallery, overlooking the Steine, and still visible in Nash's cross-section (beween pages 8 and 9). By 1819, when Nash began to construct a whole new set of apartments at the northern end of the Pavilion, the King, afflicted by gout and dropsy, negotiated stairs with difficulty thanks to his weight, and was becoming increasingly reclusive. This new set of ground-floor rooms, looking over quiet, secluded lawns, was therefore finished more with an eye to comfort and convenience than ostentation. Robert Jones was again put in charge of the decoration, and the extraordinary eclecticism of his sources – Chinese, Indian, Egyptian, Gothic and French Empire – is all the more remarkable given the sense of unity and calm that finally prevails.

The ceiling in the bedchamber is one of the most openly Gothic features of the Pavilion, though with the addition of Jones' pink dragons on a pale green background. The walls are covered with the latter's 'dragon damask' wallpaper, using the same pattern as the blue-and-silver backgrounds to his painted panels in the Banqueting Room. A block-printed version was made in 1822, but the paper-hangers' accounts for this room refer to "310 breadths of dragon green in satin pencilled by hand". The slightly submarine effect is relieved by the Brussels-weave carpet and the yellow silk used for the drapery of the bed alcove, the curtains and chair covers, all supplied by Bailey and Saunders. One of their later bills refers to a "furniture for above [the bed] of His Majesty's Lilac Silk, decorated with rich deep fringe lace etc.", so it is conceivable that the inside of the alcove was also 'dressed' soon after this aquatint view was made.

The furniture is a curious mixture of the grandiose and the insubstantial, the ornamental and the utilitarian. In pride of place in the centre is a great desk by Jacob-Desmalter, several of which were made for Napoleon – something that must have given its owner a particular *frisson* – while on the right-hand wall is a Boulle display cabinet, possibly English but with a genuine Louis XIV panel in the centre representing (rather appropriately) the Dream of Pharaoh. By contrast with these, the bamboo chairs, once in the Chinese Gallery, look frail and insubstantial. To the left of the Boulle cabinet is a washstand "fitted up with Wedgwood Ware", and apparently *en suite* with a little dressing table placed between the bed and the Jacob desk. Other, more mundane, pieces include the two pot cupboards in the alcove, the firescreen leaning up against the wall on the left, the clothes-horse, the cheval glass, and the barometer and thermometer hanging by the door to the library.

Two more gib doors are concealed in the walls to left and right of the alcove: one used by the valet, and communicating with a servants' stair behind; the other concealing a tiny *escalier de convenance*, which led to Lady Conyngham's apartments immediately above. A third, in the wall to the left of the fireplace, led to the King's bathroom, containing a great white marble tub, 16 feet long by 10 feet wide, "supplied with salt water from the sea by a succession of pipes and other machinery", and heated by an oven in the basement below.

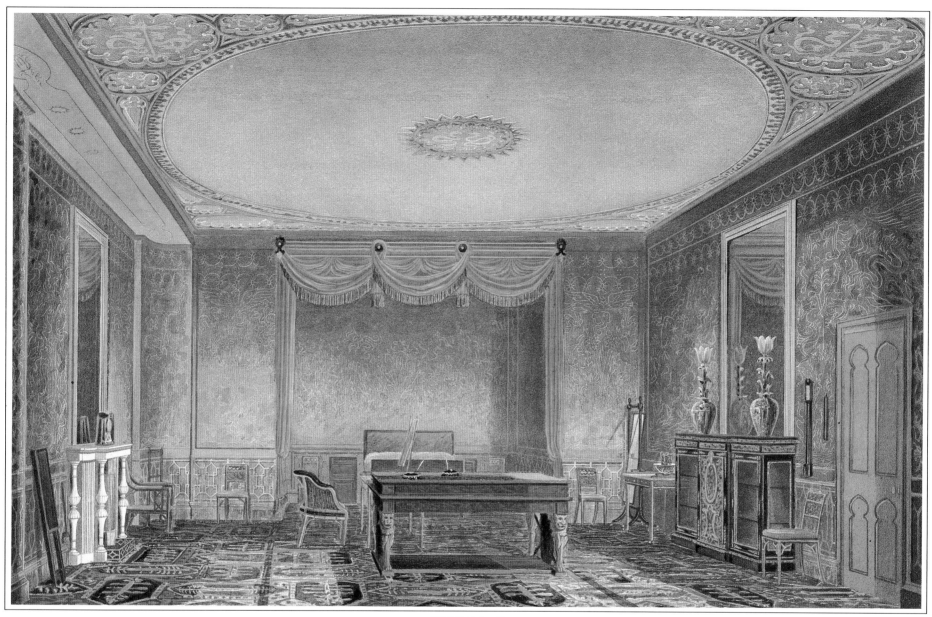

THE KING'S BEDROOM

THE PRIVATE LIBRARY

The Private Library

THIS IS THE VIEW from near the door to the King's bedchamber looking through the two libraries, which also lay behind the loggia on the west front (see page 53). All three rooms were decorated *en suite*, as can be seen here. However, Robert Jones' 'dragon damask' paper on the walls has a slightly different band of ornament at the top, and the carpet is a rather less colourful version of the one in the bedroom. Jones was paid for 'clouding' the ceiling in 1823 and for the "different greens & relieved tints of the rest of the paintwork". The four columns in the corners combine Gothic, Indian and Egyptian elements with a wonderful *insouciance*, and it would be hard to say whether the cusped arches over the bookcases are Christian, Islamic or Buddhist in origin.

George IV's love of literature was equal to his love of music, and although he gave his father's great scientific and topographical collections to the British Museum, books were always found in the rooms where he spent most time. Humphry Repton, writing in 1816, explained that "the modern custom is to use the library as the general living-room" – so to this extent the King was also following a relatively new fashion. In this instance, the shelves are built into recesses so that they are virtually flush with the walls, and have Japanese lacquer panels used as cupboard doors below. More lacquer cabinets with ormolu mounts flank the chimneypiece, and match the French secretaire between the windows. The desk in the centre, veneered with purplewood, in the French style, was made for the Prince by a London cabinet-maker named John Wacker as early as 1783. The rich but subdued tones of black, gold and green are carried through the entire room, right down to the rare black Sèvres vases with their gilt bronze dragons seen on the left-hand cabinet – and originally purchased for Carlton House in 1812.

Though keen to stress the uniformity of the room in this sense, George IV was also the kind of connoisseur who liked to mix objects of different epochs, and who could appreciate them equally as 'antiques': an attitude very different from contemporary leaders of taste like Thomas Hope. So, although there was an up-to-date French Empire garniture on the chimneypiece of the smaller library, seen in the distance, the huge mantel clock in a glass case in the first room was a Régence model with a Boulle case – of at least a century earlier.

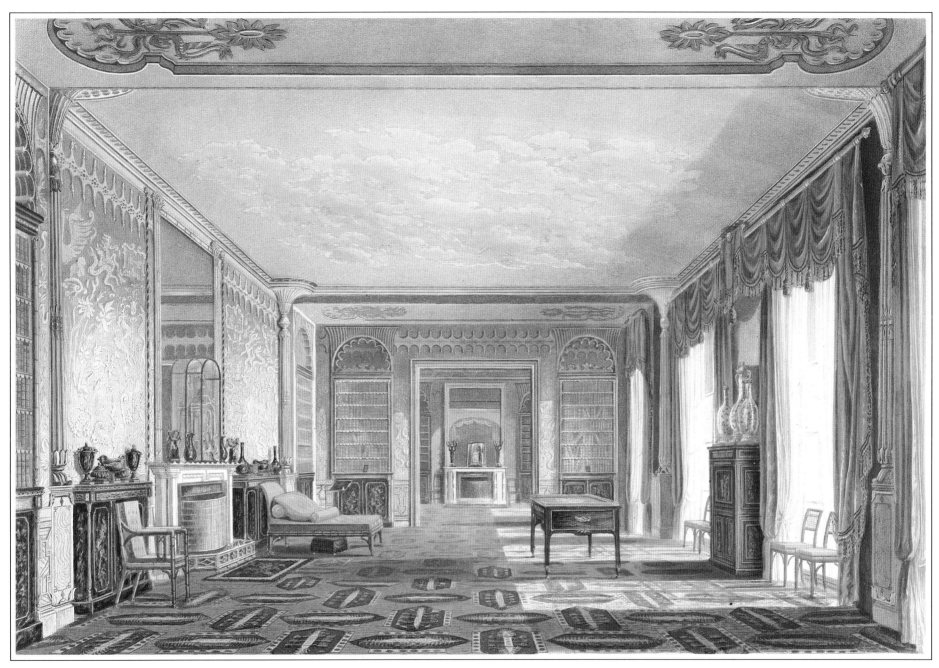

The Private Library

THE GALLERY

ON THE CHAMBER FLOOR

The Gallery on the Chamber Floor

ABOVE THE LOWER sections of the main ground-floor corridor lay two galleries, north and south, reached by Nash's cast-iron 'bamboo' staircases, and with the doors to bedchambers leading off on either side. These galleries were lit by ground-glass skylights, painted with Chinese ornaments by Frederick Crace's team, placed at the same level as the one lighting the tall central section of the Corridor (page 69). The galleries were often used as breakfast rooms for guests who stayed at the Pavilion. Madame de Boigne, daughter of the French ambassador, was "much astonished when I came out of my room to find the table laid upon the staircase landing. But what a landing and what a staircase! The carpets, the tables, the chairs, the porcelain, the china were as exquisite as luxury and good taste could possibly find." Lady Ilchester, too, thought "the effect of this centrical common room . . . very good", finding in this area "an excellent fire and books and newspapers".

This view of the South Gallery shows a couple mounting the staircase from the Corridor straight ahead, while on the left are the doors to the suite that the Prince himself occupied until 1821, when he moved to his new private apartments in the north-west wing. The decoration here probably dates from about 1815, though the curious posts flanking the doors, crowned with kylin heads, may have been re-used from the 1802–1804 period when chinoiserie ornament was first introduced to the Pavilion. The bamboo pattern on the walls consists of cut-out strips of printed paper, pasted onto a bright blue background and giving a curiously three-dimensional effect – as if the spectator had mounted the staircase to find himself in a roof-top aviary, looking through the trellis walls to a cloudless sky.

The bamboo settee, rather incongruously placed behind a Regency rosewood sofa table, must be a genuine Chinese piece, together with the tables on the far wall, and the models of junks under glass domes, that stand on them. However, the spindly single chairs, with blue leather squab seats, are of English beechwood, carved and painted to look like bamboo. The only object of outstanding quality is the French ormolu cartel clock, seen on the right-hand wall. The Brussels-weave carpet, almost certainly from Axminster, like the other examples in the Pavilion, has an especially pretty floral pattern.

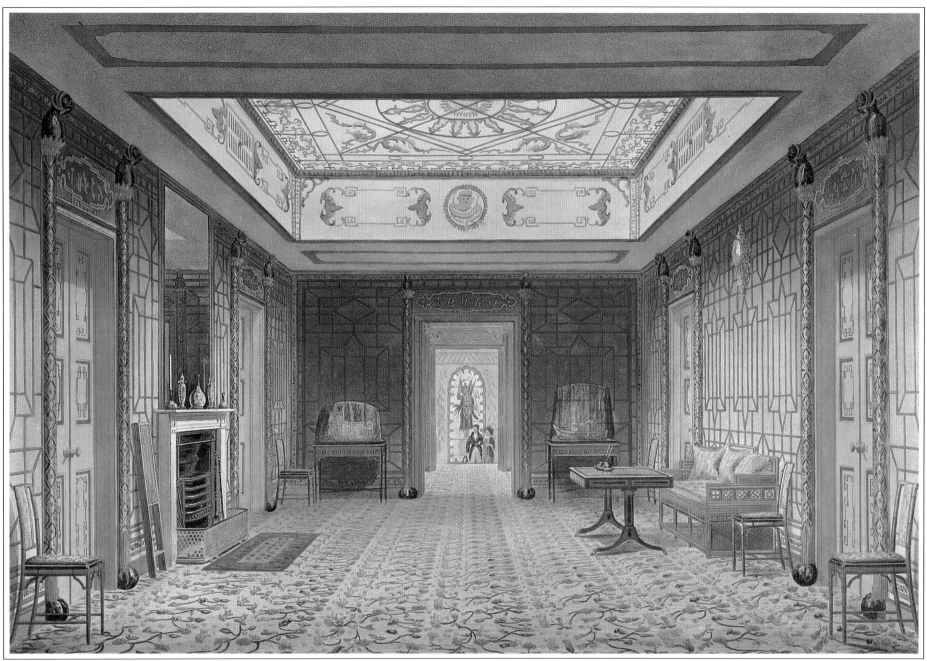

THE GALLERY ON THE CHAMBER FLOOR

THE GREAT KITCHEN

The Great Kitchen

BUILT BY NASH in 1816, long before the adjoining Banqueting Room was ready for use, the Great Kitchen was a source of enormous pride to the Prince Regent: hence its inclusion in Nash's book. As the Comtesse de Boigne records, "if . . . he happened to meet any new-comers to the Pavilion, he took delight in showing them over the palace himself, a special point being his kitchens, which were entirely steam-heated by a system at that time new, with which he was charmed". On one occasion he even arranged to dine here with his servants, having had a red cloth laid upon the floor.

The Prince's love of good food was celebrated, and many of the great chefs of the day worked here. These included the famous Carême, inventor of caramel, who was brought over from France in 1816, and who prepared the splendid dinner for Grand Duke Nicholas of Russia (later Tsar Nicholas I) given at the Pavilion in January of the following year. The menu for this occasion lists over a hundred dishes, with "La ruíne de la mosquée turque" and "L'hermitage chinois" among the "Grosses Pièces de Patisserie".

J. W. Croker noted that "the kitchens and larders are admirable – such contrivances for roasting, boiling, baking, stewing, frying, steaming and heating; hot plates, hot closets, hot air and hot hearths, with all manner of cocks for hot water and cold water, and warm water and steam, and twenty saucepans all ticketed and labelled, placed up to their necks in a vapour bath."

The roasting spits above the open fire, seen on the right, were worked by a smoke-jack high up in the chimney, powered by the rising heat. The huge oval steam table in the centre has gone, but otherwise the room looks very much the same today, with copper canopies over the range and hearth, the same lanterns (now electrified, but originally equipped with Argand burners), and even the same clock above the gleaming 500-piece *batterie de cuisine* on the north wall of the kitchen.

The slender cast-iron pillars supporting the huge span of the roof and lantern are examples of Nash's engineering skill, shown in so many other rooms in the Pavilion. The preliminary line-engraving does not show their palm-tree tops, but these were added by an ironmonger named Palmer at a cost of £80 in April 1820 –and the detail was painted into the aquatint– so that even the kitchen should conform to the Oriental theme.

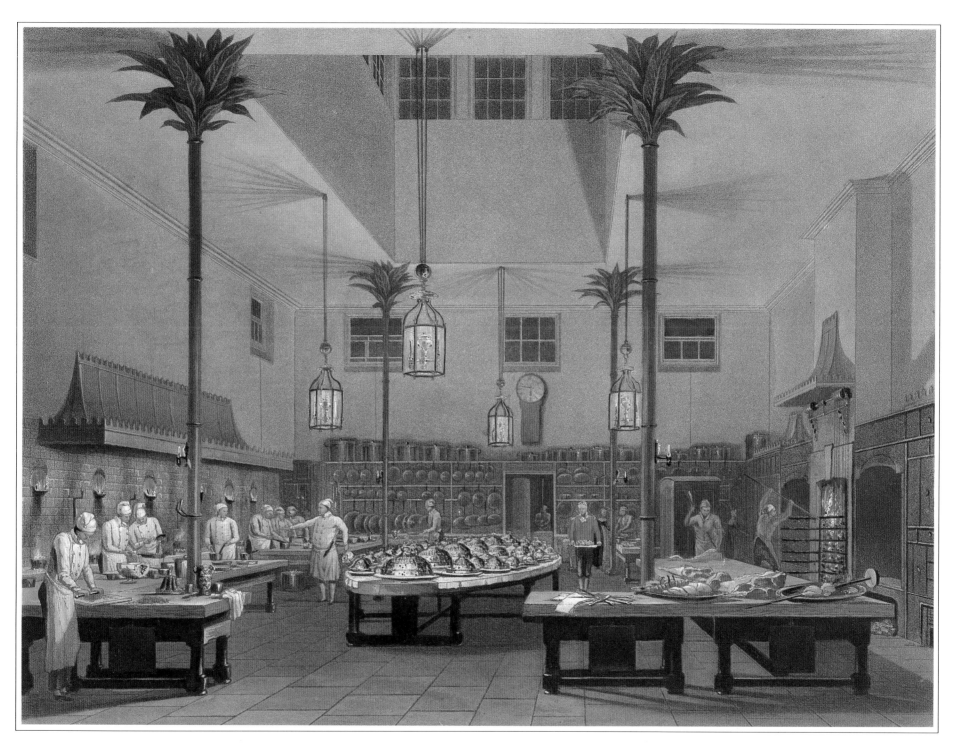

THE GREAT KITCHEN

PERSPECTIVE VIEW OF
THE STABLE BUILDING

Perspective View of the Stable Building

" . . . A STUPENDOUS AND magnificent Building, which by its lightness, its elegance, its boldness of construction, and the symmetry of its proportions does credit both to the genius of the Artist, and the good taste of his Royal Employer". Humphry Repton's verdict on the Prince Regent's new stables at Brighton was written in 1805 when the building was by no means complete, but it suggests how impressed contemporaries were with William Porden's design, and explains how it became the catalyst for the whole transformation of the Pavilion in the Indian style after 1815.

The original stable yard lay to the south of Holland's 'marine villa' with an entrance from Castle Square. It was big enough to hold forty horses (as opposed to sixty in Porden's new building), so it was probably abandoned not on grounds of size, but because the space was needed for larger domestic offices and servants' quarters. In 1803 a new plot of land was bought to the north-west, and Porden was appointed architect – at the same time building a house for Mrs Fitzherbert at the south-west corner of Castle Square. His introduction to the Prince may have come through the 2nd Earl Grosvenor, who had just commissioned him to reconstruct Eaton Hall in Cheshire, the most extravagant Gothic house of the Regency period. Both patrons were addicts of the turf, and indeed the Prince's need to keep racehorses at the Pavilion – not far from Goodwood and the famous Charlton Hunt Club – may explain why he wanted them housed in such style.

Porden had started as a pupil of James Wyatt, and then worked with S.P. Cockerell, who was now in the process of building an 'Indian' country house for his brother at Sezincote in Gloucestershire. However, his own interest in the style was evident as early as 1797, when he exhibited at the Royal Academy "a design for a place of amusement in the style of the Mahometan architecture of Hindustan". Carried away by the idea of a royal commission, his design for the Brighton stables proposed a vast circular building with a central manège or ring covered by a dome 65 feet high, and 80 feet in circumference. This dome was consciously modelled on Le Grand's Halle au Blé, or corn exchange, built in Paris in 1782 and compared at the time to some of the great monuments of Imperial Rome.

Even the architect must have been somewhat surprised when this megalomanic scheme was approved by the Prince, who seems temporarily to have been in funds, while his more modest schemes for the Pavilion itself were rejected. By November 1804, the building was already so well advanced that Porden could write to his daughter: "The cupola is now on, and the workmen are swarming about like jackdaws. The whole proves fully equal to expectation. The dome now supports itself; without assistance from the scaffolding and has *not yet fallen.*"

What did not prove equal to expectation was the depth of the royal purse, and this explains the constant delays, and the distress caused to unpaid workmen, over the next few years. In January 1807, Porden complained to the Prince's secretary that "the naked timbers of the Riding House [on the left in this view] stand exposed to all weathers, a monument of disgrace to His Royal Highness and all concerned." By April 1808, when it was completed, the whole block had cost almost £55,000, and, even then, the tennis court originally planned on the east had been abandoned, and the right-hand section of the façade seen here was built merely as a sham wall to complete the façade.

Porden's 'Indian' style, influenced by George Dance's London Guildhall of 1788, was in fact only skin-deep. The multifoil pointed arches, and the tripartite composition of the centre and wings, with colonettes carried up into pinnacles above the flat parapets, can be traced back to celebrated Indian buildings like the great Jami' Masjid at Delhi, illustrated in the Daniells' *Oriental Scenery*. Yet the overall proportions are unmistakably classical. In the end, the revolutionary nature of the building lay in the influence it was to exercise, rather than its inherent novelty.

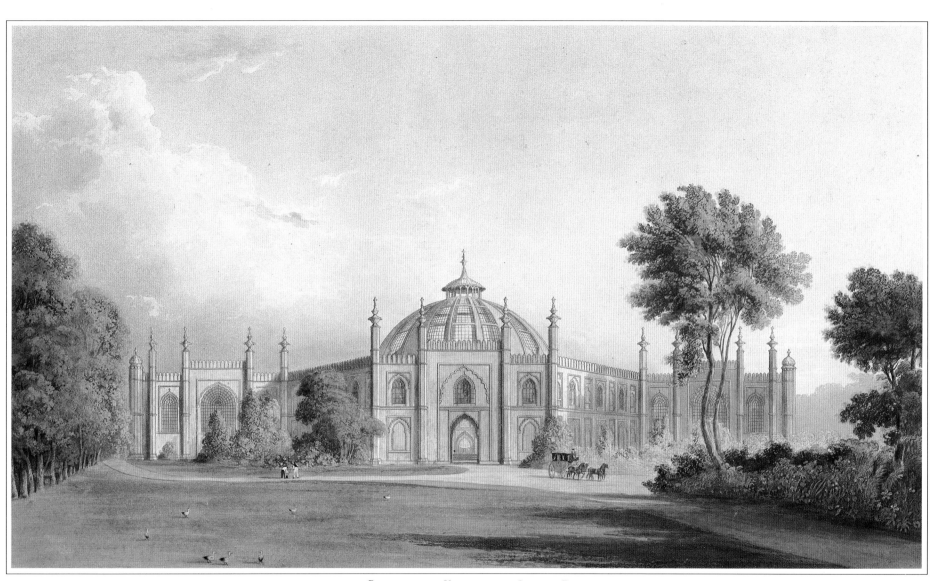

PERSPECTIVE VIEW OF THE STABLE BUILDING

INTERIOR OF
The Rotunda

Interior of the Rotunda

THE CENTRAL ROTUNDA within Porden's stable block, constructed of yellow brick with Bath stone dressings, quite lived up to its spectacular exterior. The sixteen glazed panels of the dome, strengthened by encircling cast-iron ribs, gave a feeling of great lightness to a space that might otherwise have seemed like a somewhat claustrophobic well. Much of the ornament looks more Gothic than Indian, including the inverted arches at the bottoms of the panels, and the double row of thin pilasters below. Even Repton, who so greatly admired Porden's building, found that the dome "resembles rather a Turkish Mosque than the buildings of Hindustan". On the other hand, the fan-shaped glazing bars of the ground floor windows, recalling the conservatory at Sezincote, in Gloucestershire, the repeated multifoil mouldings of the entrance arch, and the central lotus-leaf fountain, have enough Mogul associations to satisfy the Prince's romantic yearnings. A kind of Oriental answer to the Pantheon, devoted to the celebration of the horse, it must have seemed an extravagance worthy of an Alexander.

Altogether there were 44 stalls radiating off this central space, with more for coach and carriage horses in the open rectangular courtyard beyond, giving on to Church Street. The grooms' and stable boys' quarters lay off the first floor gallery, approached by staircases within the open arches seen on each side. Two racehorses wearing check blankets and blinkers are being ridden in, while another is being groomed on the right. Smell was a problem in such an enclosed space, but Porden's lantern, crowning the dome, acted as an efficient ventilator.

The stables were converted into an Assembly Room by Brighton Corporation in 1867, and the rotunda was remodelled internally as a concert hall (now the Dome Theatre) in 1934–35.

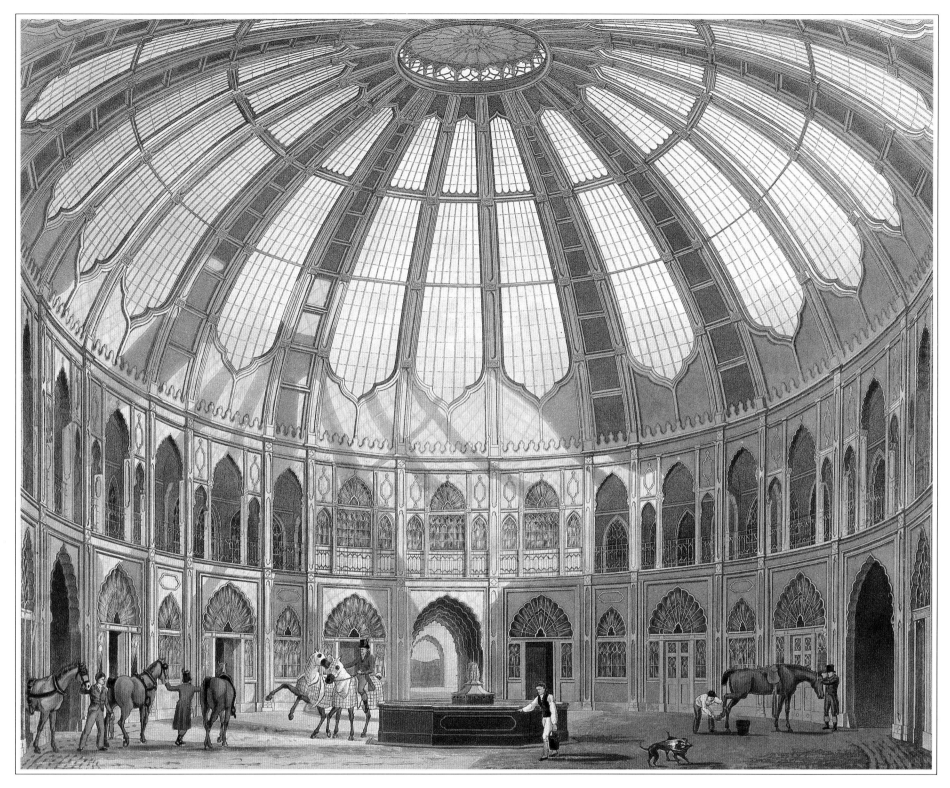

Interior of the Rotunda

THE STABLES

AND

THE RIDING HOUSE

The Stables (towards Church Street) and The Riding House

THE LONG NORTH front of Porden's stables was a more pedestrian affair than the façade facing the garden and the Pavilion, dominated by the huge dome of the rotunda. The three great windows on the right belonged to the indoor riding school, while those on the left were to have served the real-tennis court, abandoned because of lack of funds, and only completed as 'Queen Adelaide's Stables' in the 1830s. The ground plan in Nash's *Views* (page 25) does not show this part of the façade completed, so it is probable that this aquatint was made assuming that it would follow shortly. The blank windows either side of the central gatehouse represent carriage houses, open to the courtyard on the other side, while the glazed windows beyond served some of the stalls for coach-horses.

Once again the Indian veneer of the building is quite thin, and the two end sections have an uncanny resemblance to Hawksmoor's Gothic façades of the great hall and Codrington Library at All Souls College, Oxford, facing the Radcliffe Camera. Sentries can be seen guarding the gate, and a procession of fashionable Brighton figures on their way to or from the Steine, glimpsed on the far left.

INDOOR RIDING SCHOOLS, inevitably found attached to the castles of the German and Austrian nobility, are a comparative rarity in England – though there are exceptions to the rule, like Welbeck and Bolsover in the seventeenth century, and Hovingham and Calke Abbey in the eighteenth. The Prince Regent's Hanoverian ancestry, and his love of equestrian sports of all kinds, encouraged him to build a large rectangular hall as part of William Porden's stable block, where his beloved hussars could practise their exercises in bad weather, and where dressage and other competitions could be held. A box for spectators was provided high up on the east side, reached from one of the staircases in the adjoining rotunda, and provided with a drapery curtain as if it were in an opera house.

The shallow barrel-vaulted ceiling built in the form of a shallow arch, without tie beams, demonstrates William Porden's engineering skills. According to Brayley, who added a cross-section of the stable block to his edition of Nash's *Views* in 1838, it was constructed in "three thicknesses of fir plank". The walls are also lined out with wood, perhaps to avoid an overpowering echo.

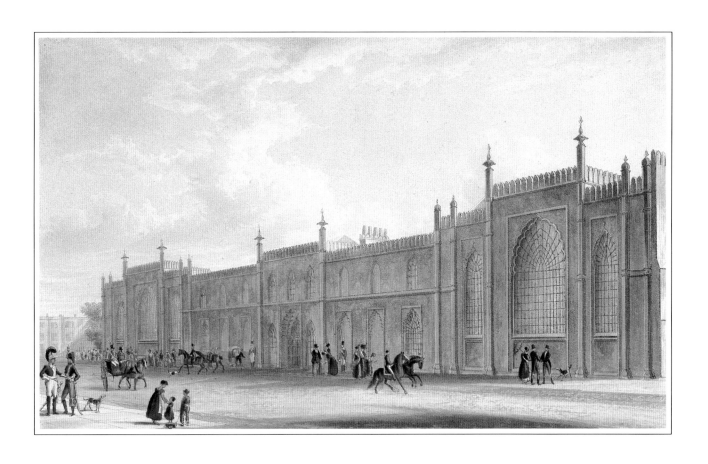

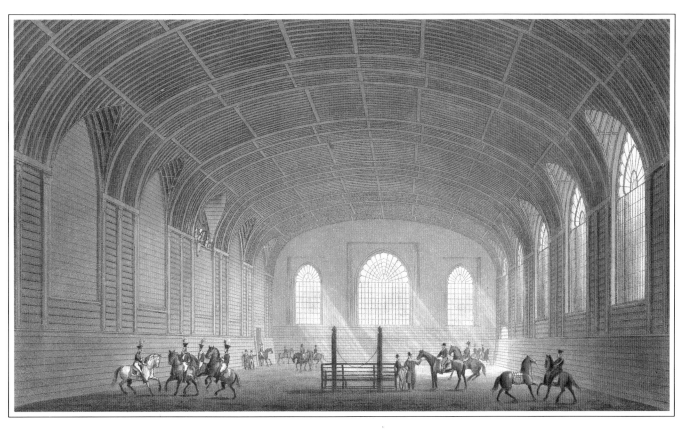

The Stables and The Riding House

Section through the State Apartments

PERHAPS THE MOST remarkable of all the illustrations in Nash's *Views* is this huge longitudinal cross-section of the pavilion (*See illustration, between pages 8 and 9*). Originally made to fold out, as here, it shows the sequence of five main state rooms along the east front, together with the bedchambers and dressings rooms above the Music Gallery and Banqueting Room Gallery, and the Great Kitchen on the far right – all in exquisite detail. It seems likely that this was the last of all the aquatints made for the book by Augustus Pugin, since it shows the cabinets in the Saloon, designed by Robert Jones and made by Bailey and Saunders, which had not been completed by the time the general view of the room (page 89) was published in June, 1823. A number of Pugin's pencil drawings for the window walls of the five state rooms still survive at the Pavilion, and must have been undertaken in connection with this one plate, showing the scale of the whole enterprise. The structural details are just as faithfully delineated, and were probably based on a series of measured drawings made by the Clerk of Works, William Nixon, at Nash's request.

The cross-section fully justifies the architect's pride in the cast-iron frame which he devised for the central dome. Immediately above the saloon can be seen the timber structure of Holland's original shallow dome, while above it is the iron cage supporting the dome and resting on the outer walls. This cage was actually big enough to contain three rooms, but their walls are cut away to show the structure and only part of their floors are shown. The mastic with which the roofs were covered was, of course, lighter than lead, as well as cheaper, but the necessary engineering skills were still formidable. The cast-iron cores of the minarets are also revealed in the two flanking the central dome. The full timber structure of the subsidiary domes is displayed in the one immediately to the left of the Saloon, while the others are shown in true cross-section, and thus look less complex.

The simple box-like form of the Music Room and Banqueting Room is also evident here. Their great sagging canopies, painted to look like bamboo and embossed leather respectively, hang from straightforward lean-to roofs, while their domes are suspended from the timber roof-structures with their 'tented' outline. Cast-iron elements are again used at key stress points, and as cores for the central finials.

The Banqueting Room Gallery, with its green silk curtains, is accurately shown with a lower ceiling than its counterpart on the north, for this section of the building still preserves the basic structure of the existing farmhouse rented by the Prince in 1786. His bedroom and dressing room lay immediately above, while the boudoir between them was created in 1802–1804 in place of the original staircase. Its magnificent tented decoration, in blue silk, framed a daybed on the inside wall, and "around this were reflecting glasses, which enabled His Royal Highness, while reclining on his pillow, to see the promenade on the Steine very distinctly." A telescope was kept, for the same reason, in the adjoining dressing room. Soon after becoming King in 1820, George IV moved to the new private apartments at the north end of the Pavilion, and these rooms were later occupied by his sister, Princess Elizabeth of Hesse Homburg.

The apartments over the North Drawing Room, part of the extension Holland had made to the Pavilion in 1787, were usually reserved for the King's brothers, the Duke of Clarence (later William IV) and the Duke of York. Each is shown here with a splendid French *lit bateau*, placed against the wall, with a canopy above it, and with furniture to match. Chinese paintings were hung on the walls: oils to go with the satinwood suite, and watercolours with the mahogany. The little room between was given to a valet.

It would be impossible to describe all the fascinating details to be found in this *tour de force* of the aquatinter's art, but two more deserve a final mention: the pipework and bellows of the gigantic organ, occupying a room of its own on the far left, and the smoke-jacks concealed in the chimney flue of the Great Kitchen on the far right.

Acknowledgements

So much has been written about the Pavilion that it would be hard to claim great originality for the commentaries that accompany the plates in this edition. Apart from John Morley's book, *The Making of the Royal Pavilion, Brighton* (1984), a particular debt of gratitude is owed to John Dinkel's *The Royal Pavilion, Brighton* (1983), much the best account of the architecture and decoration of the building since Henry D. Roberts' *History of the Royal Pavilion* (1939). Sir Geoffrey de Bellaigue's section on the 'Works of Art' in the volume on *Buckingham Palace* (1968), written in collaboration with John Harris and Sir Oliver Millar, has also been consulted.

I am most grateful to Sir Geoffrey (now Director of the Royal Collection) and Hugh Roberts (Surveyor of the Queen's Works of Art) for reading the text, together with Dr Richard Marks, Director of the Royal Pavilion, Art Gallery and Museums, Jessica Rutherford, Acting Director, David Breuer, Marketing Manager, and other members of the Pavilion staff. I should also like to thank Colin Webb of Pavilion Books for inviting me to write the text, Caroline Dawnay of Peters, Fraser and Dunlop, Louise Simpson, also of Pavilion, who edited the book, and, as always, Maggie Grieve of the National Trust.

G.J.S.